IMAGES
of America

WHEATON

Richard Crabb (1911–1999), journalist and Wheaton resident, wrote several readable and authoritative histories, including *Empire on the Platte*, *The Hybrid Corn-Makers*, *Radio's Beautiful Day*, and *Birth of a Giant*. Additionally, he was the founder of the DuPage Heritage Gallery, and wrote for several Chicagoland newspapers. Partnering with Jean Moore, he composed a series called *Great People of DuPage*, showcasing prominent area personalities. Singly and together, they were incomparable researchers, providing much invaluable information; and in 1989, they were named official DuPage County historians. Belatedly, but not too late, the author recommends Crabb and Moore to the gallery of DuPage greats. (Courtesy of Wheaton College Archives and Special Collection.)

On the cover: Citizens congregate on the front lawn of the DuPage County Courthouse for a patriotic celebration, 1920. (Courtesy of the Wheaton Historic Preservation Council.)

IMAGES
of America

WHEATON

Keith Call

Copyright © 2006 by Keith Call
ISBN 0-7385-4035-8

Published by Arcadia Publishing
Charleston SC, Chicago IL, Portsmouth NH, San Francisco CA

Printed in the United States of America

Library of Congress Catalog Card Number: 2006921052

For all general information contact Arcadia Publishing at:
Telephone 843-853-2070
Fax 843-853-0044
E-mail sales@arcadiapublishing.com
For customer service and orders:
Toll-Free 1-888-313-2665

Visit us on the Internet at http://www.arcadiapublishing.com

For the Kinnamans, Toof, Walt, Spike, and Boots—
Wheaton's royal family.

Contents

Foreword		6
Introduction		7
1.	Pomfret on the Prairie	9
2.	Wheaton College	37
3.	The Theosophical Society	83
4.	Saints' Rest	99
5.	All-American, Cosmopolitan City	111
Acknowledgments		128

Foreword

Every town has its own unique characteristics and colorful history. Wheaton, Illinois, was established around 1837, and over the next 150 years or so, flourished from a vast prairie into a cosmopolitan suburb of Chicago. In some ways, Wheaton was more progressive in its early years than it was in the middle of the 20th century. In the beginning, the development of stores, churches, schools, and transportation were priorities to attract families and businesses. But by the 1960s, expansion of its borders was not appealing to city government. New towns around Wheaton were established and open land was procured by existing towns, leaving Wheaton as an island surrounded by progress. Industry had escaped Wheaton's hold. By the turn of the 21st century, in 2000, this city was well aware of its shortcomings—there was no more land to develop. Progress then meant redevelopment. Apartment buildings had been torn down for housing and businesses on land that now holds condominiums. Fortunately most of the architectural character of the 1900s in the business area has been preserved or replicated, partially due to Wheaton's conservative economic development efforts. Wheaton was and still is a remarkable community because of its combination of progressive and conservative governments. All through the years, a continuous desire toward improving the quality of life is evident by the role the arts and humanities played. Individuals and institutions were encouraged to explore their beliefs and interests—and they prospered. Wheaton is known nationally and even internationally for its contributions to education, religion, science, show business, sports, and link to political connections and the horrific tragedy of September 11, 2001. This publication touches on some of the lesser known, yet historically significant individuals and institutions that have called Wheaton home.

— Alberta Adamson
President and CEO for the Center for History,
a facility of the Wheaton Historic Preservation Council

INTRODUCTION

"What's so GREAT about Wheaton?" demands a 1969 promotional booklet published by the Chamber of Commerce. What, indeed?

Wheaton, Illinois, is the 12th train stop west on the Chicago/Geneva line. A city of approximately 55,000, it is bracketed between Glen Ellyn and Winfield and boasts two depots instead of one.

Long ago, urban sprawl in its relentless creep absorbed Wheaton into the amorphous blob called "Chicagoland." Villages like Oak Park, Elmhurst, Schaumburg, and Evanston, once solitary on the dusty prairies, are now forcibly joined by a connective tissue comprising endless tracts of strip malls, tollways, and condominiums. Regardless, vestiges of their quaint identities steadfastly remain, despite the developers' best efforts to obliterate it. The mere fact that Wheaton remains a stop on the line is but one example of its endurance, for it was the prospect of the railway that opened the city to its lasting life.

When the Erie Canal at last opened in New York in 1825, New Englanders picked up and headed westward, trudging across plains and over mountains and toward the ocean; but a few stopped here on the middle plains near the Great Lakes, tempted by tales of rich, productive soil. Among these hardy pioneers was Charles Gary of Pomfret, Connecticut, who explored Northern Illinois seeking adequate land for farming. Soon his brother, Erastus, joined him to plant crops. After the 1832 Black Hawk War, enticement to travel increased for those still living in the East; and the region saw yet another influx. Meanwhile, the Garys constructed grain and sawmills, servicing the community with lumber for furniture and homes. Five years later, the Garys' friends from Pomfret, Warren and Jesse Wheaton, also moved west, along with many others. As they settled and surveyed, the Garys and Wheatons soon realized that one vital component was missing to complete a fully functioning community: a railroad. Owning large chunks of land by the mid-1840s, they could easily afford to give two and a half miles of right-of-way to the Galena and Chicago Union Railroad, later the Chicago and North Western. In gratitude, railroad representatives J. B. Turner and W. B. Ogden built a station in the little community and named it Wheaton.

The second gift of land insured another terrific boost to the community. When the Wesleyans decided to build their denominational college here, Warren Wheaton donated a large tract of land, on which Illinois Institute was constructed. The school struggled for seven years, drained by bankruptcy, until the Congregationalists took over, installing Jonathan Blanchard as president in 1860. Blanchard renamed it Wheaton College, honoring its benefactor. The city owes much to his generosity.

Soon there were schools and shops, a post office, and churches. Literally pulling itself out of the mud, the city was incorporated as a village in 1859, with Warren Wheaton acting as its first president. After a bit of wrangling with Naperville, Wheaton even acquired the distinction

of acquiring the DuPage County seat in 1867. The following year, the first courthouse was completed. At last in 1890, Wheaton was incorporated as a city.

With the arrival of the Aurora, Elgin and Chicago Railway, running on the "third rail," the population boomed. As Chicago's industrial fortunes exploded sky high, successful businessmen like Medill McCormick, former publisher of the *Chicago Tribune*, and the Morton family, owners of the salt company, looked to Wheaton as their "country" home.

In fact, the flow of wealth allowed for the construction of several stately homes, a signature of the city. Many of these luxurious residences are profiled in Graham Burnham's *Wheaton and Its Homes* (1892), written to attract prospective citizens. With silvery tones he writes:

> Reclining in the shadow of Chicago's fame, and modestly deigning to receive the gentle side glances and flattery of Chicago's admiring courtiers, a galaxy of favored suburban residence places add their charm and rustic naiveté to their queen's imperial greatness, finding reward for all their grace in that inevitable prosperity which flows into the coffers of kings and queens. Chief among these suburban places is Wheaton.

Later he observes, "So long has this spirit of reticence and conservativeness surrounded Wheaton that it seems almost like a sacrilege to break through it, and to speak in print of the merits of the place."

Thus were Burnham's genteel Victorian reservations. These days we do not mind trumpeting the merits of the place. On these tree-lined acres you will find actors, poets, theologians, mystics, politicians, merchants, students, and doctors, all milling peacefully about their business. Among our various archives and museums you will find C. S. Lewis's private wardrobe, Jonathan Blanchard's battered top hat, J. R. R. Tolkien's desk (on which he wrote *The Hobbit*), Madame Blavatsky's tiara, Oswald Chambers' interleaved Bible (with extensive handwritten notes), Malcolm Muggeridge's typewriter, and the still-strong bones of a hulking mastodon.

And much more.

As you read, perhaps you will notice that a familiar personage is not presented. For the most part, I have avoided discussing individuals well-documented elsewhere. Regarding more comprehensive treatments of prominent residents, please consult the Wheaton College Archives and Special Collections, the Center for History, and the DuPage County Historical Museum. Their staffs will happily assist you.

What's so great about Wheaton?

The answers patiently await in the pages ahead.

One
Pomfret on the Prairie

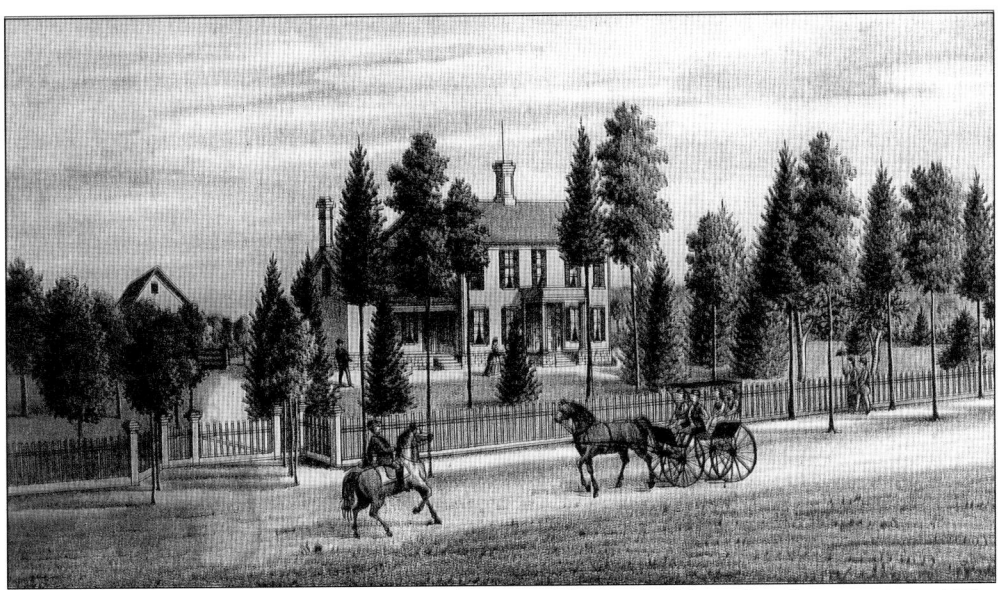

Frank Herrick, regional poet, writes in "Wheaton – My City": "I love thy pleasant views, / Thy tree-lined avenues, / Tranquil and sweet; / I love thy welcome shade / Where stately elms have made / a leafy colonnade / Whose branches meet!" Centuries before the tranquility, before the advent of New England settlers, Native American tribes such as the Illini, Sauk, Fox, Pottawatomie, and Ottawa tramped the valleys and grasses of the middle prairies, often warring but sometimes grudgingly coexisting. As late as the mid-1850s, long after the 1832 Black Hawk War that drove the Native Americans into Iowa, DuPage County pioneer families narrated inherited fireside tales of peaceful nighttime visits from American Indians. By then, American Indian life had faded into romantic memories; for good or ill, a new people with a new range of experiences would dominate. As the Garys and Wheatons platted their pristine acreage, they intended for the burgeoning community to resemble their hometown, Pomfret, Connecticut, a sturdy, productive New England village. Pictured is Jesse Wheaton's house, one of the oldest homesteads in the city, at 310 Evergreen Street. Warren's home now functions as a real estate agency, appropriately. (Courtesy of the Wheaton Historic Preservation Council.)

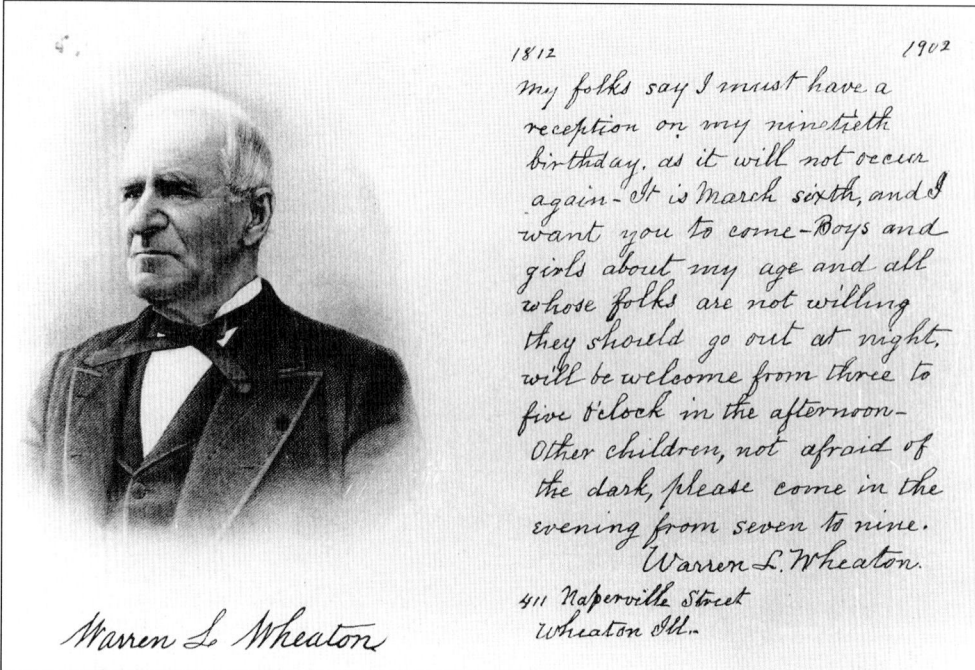

In this charming little note, Warren Wheaton happily invites both little and big kids to his 90th birthday party. For all of his life, Wheaton remained intensely close to the affairs of his namesake city. (Courtesy of Wheaton College Archives and Special Collections.)

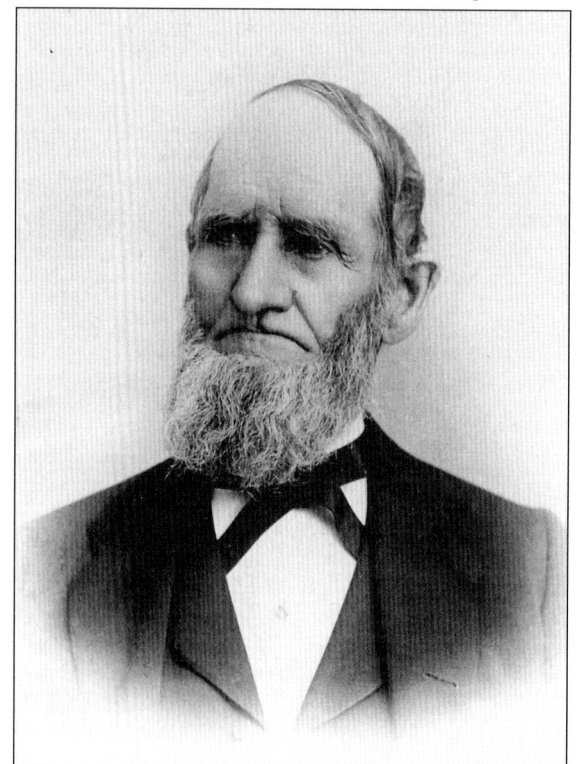

Warren's brother, Jesse, married Orinda Gary in 1839, settling in their abode located at 310 West Evergreen Street, the homestead for generations. (Courtesy of Wheaton College Archives and Special Collections.)

Sailing with others from New England through the Erie Canal, Lyman Butterfield arrived in 1831. From Chicago, he moved west on an American Indian trail, now called Butterfield Road, a northern border for the Danada Forest Preserve. Once rural, Butterfield Road connects endless miles of malls, fast-food eateries, and nondescript townhomes. (Courtesy of the Wheaton Historic Preservation Council.)

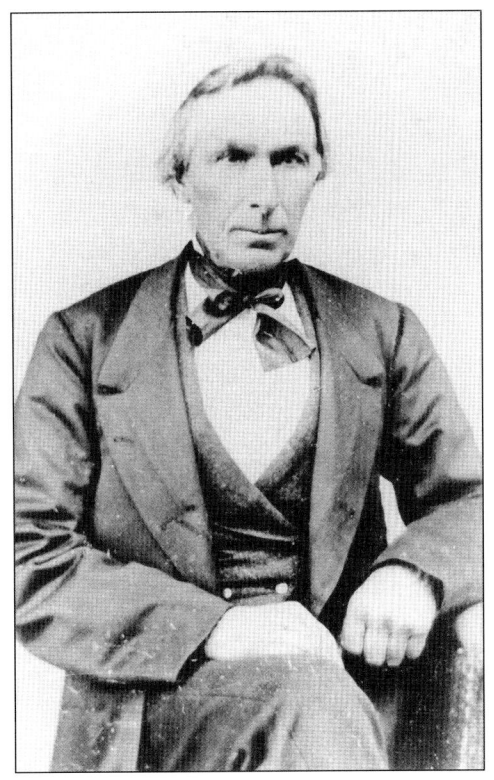

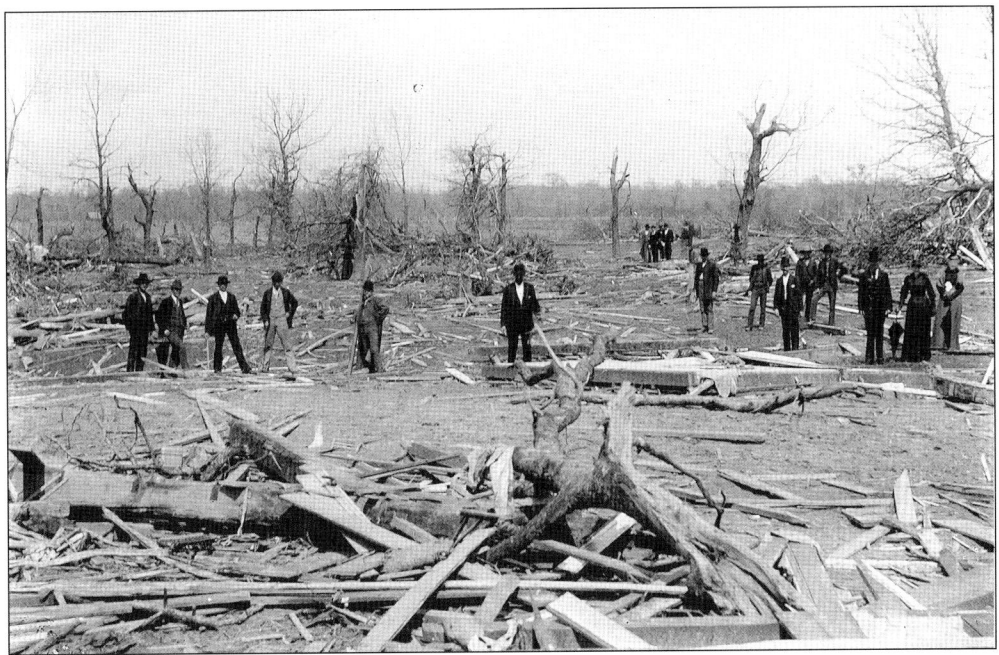

This photograph shows severe tornado damage inflicted upon Wheaton in the 1890s. Wide open on the plains, the little town was often vulnerable to nature's wrath. As seen here, citizens stoically clean up the mess and move forward. (Courtesy of Wheaton College Archives and Special Collections.)

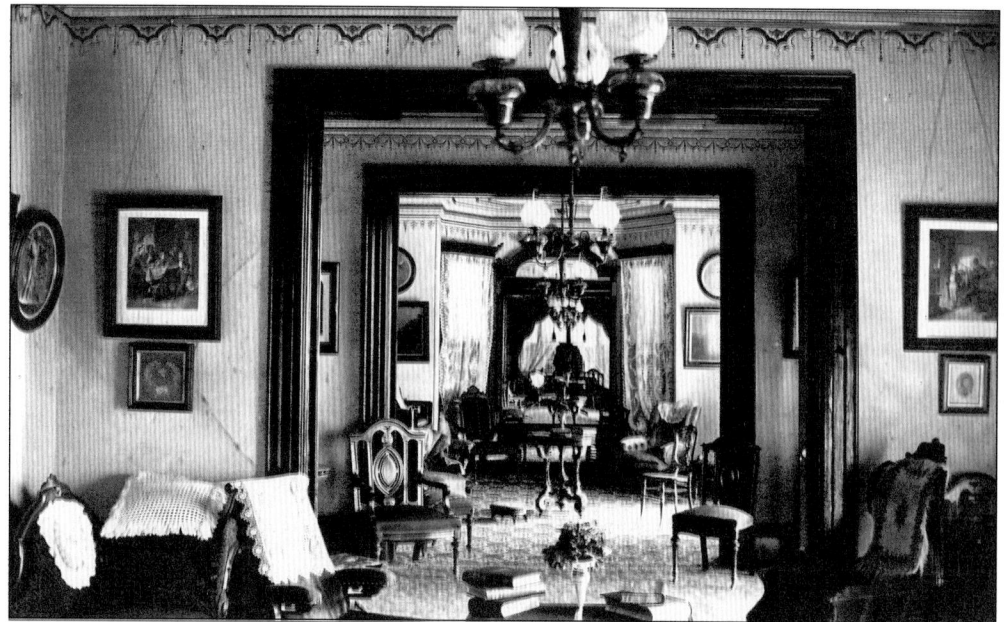

This photograph shows the parlor of the Reverend J. P. "Uncle James" Stoddard's home. A graduate of Wheaton College and close associate of the Blanchard family, he served as the secretary and general agent for *The Christian Cynosure*, the anti-Masonic newsletter. (Courtesy of Wheaton College Archives and Special Collections.)

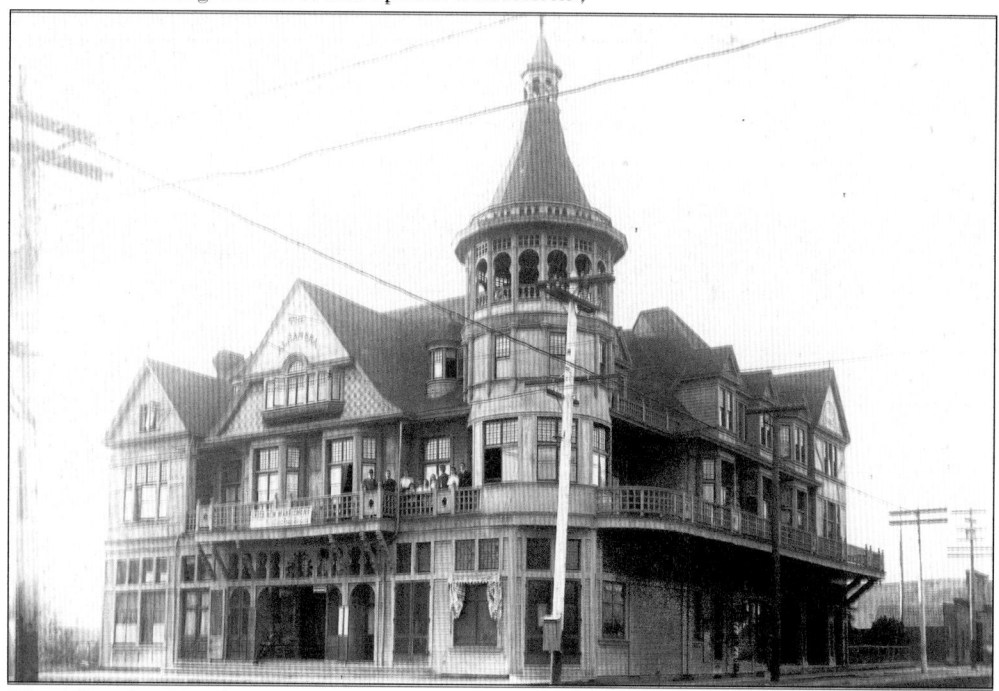

The Alhambra Hotel is seen here in the early 1900s, servicing travelers stopping on the railway. Like other inns of the era, the Alhambra offered a full line of excellent service: beds, food, shoe-shining, and so on. This dashing house is long gone. (Courtesy of Wheaton College Archives and Special Collections.)

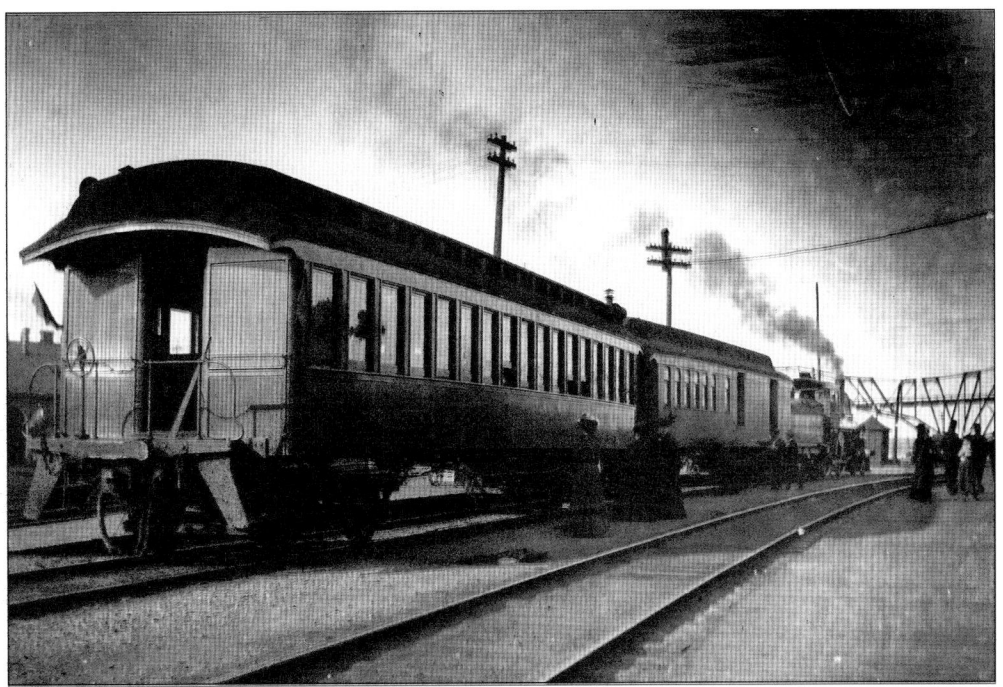

Wheaton was the primary hub for the Chicago and Northwestern, which pulled both freight and passenger trains. (Courtesy of Wheaton College Archives and Special Collections.)

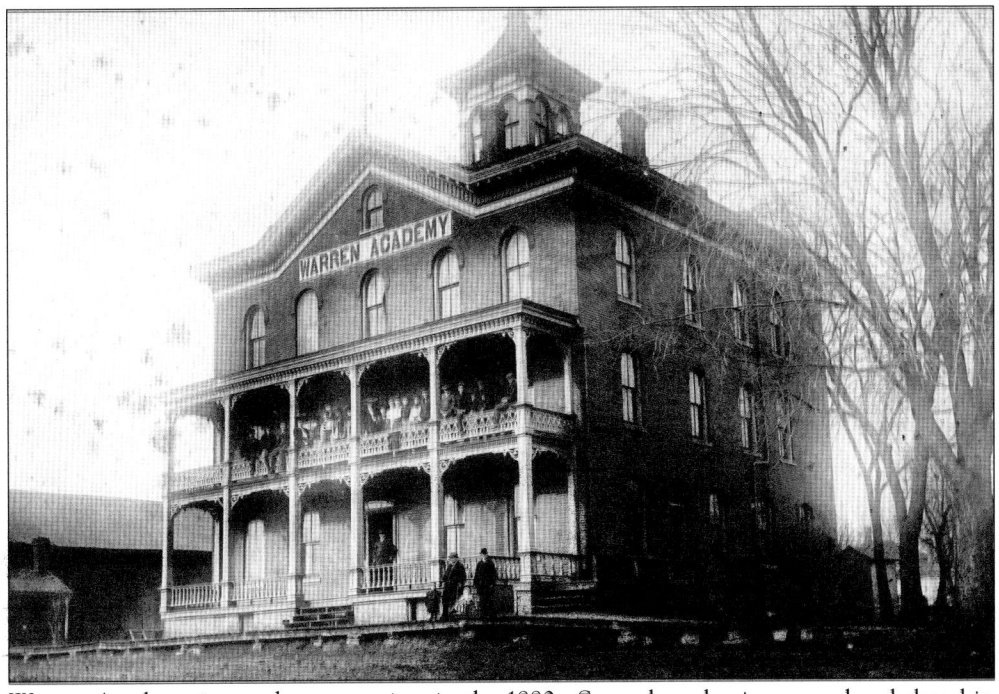

Warren Academy is seen here sometime in the 1880s. Several academies opened and closed in the late 19th century. Little is known about Warren Academy. (Wheaton College Archives and Special Collections.)

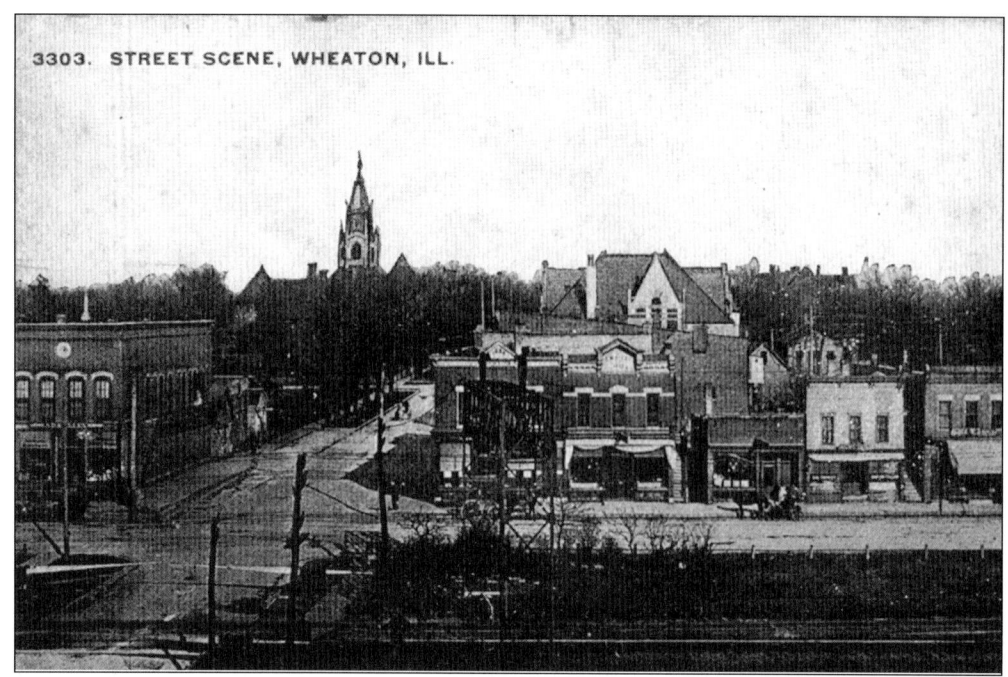

This interesting view of Front Street displays a full complement of Wheaton businesses situated parallel to the railroad tracks. The great tower dominating the background arises from Gary Methodist Church in this c. 1910 photograph. (Courtesy of the Wheaton Historic Preservation Council.)

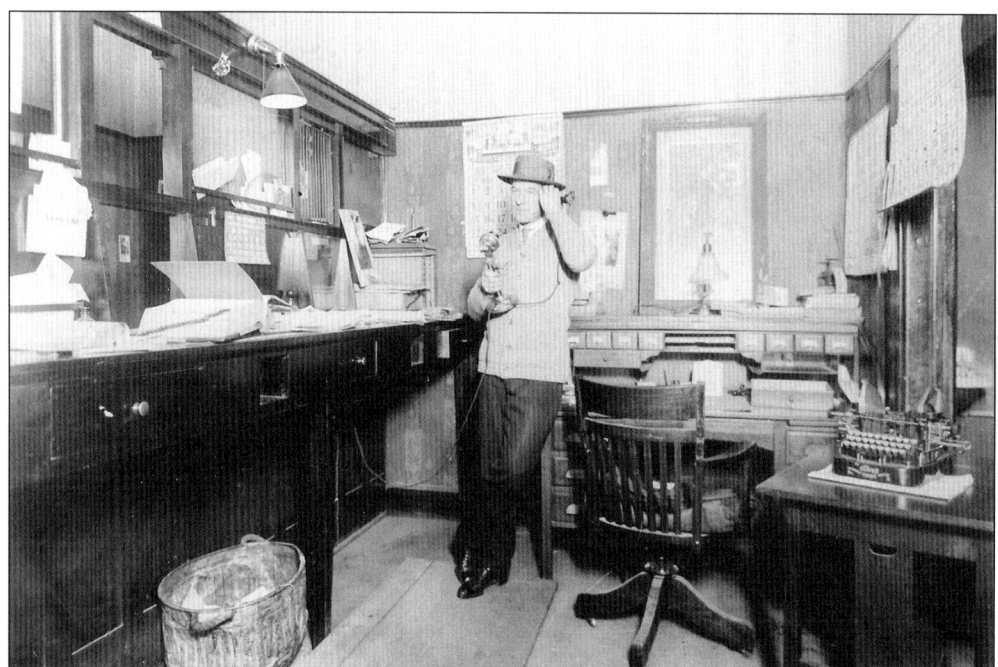

Fred Peironnet talks on the phone, probably business not pleasure, in 1912. The Peironnet Coal Company was located at 105 North Main Street. (Courtesy of the Wheaton Historic Preservation Council.)

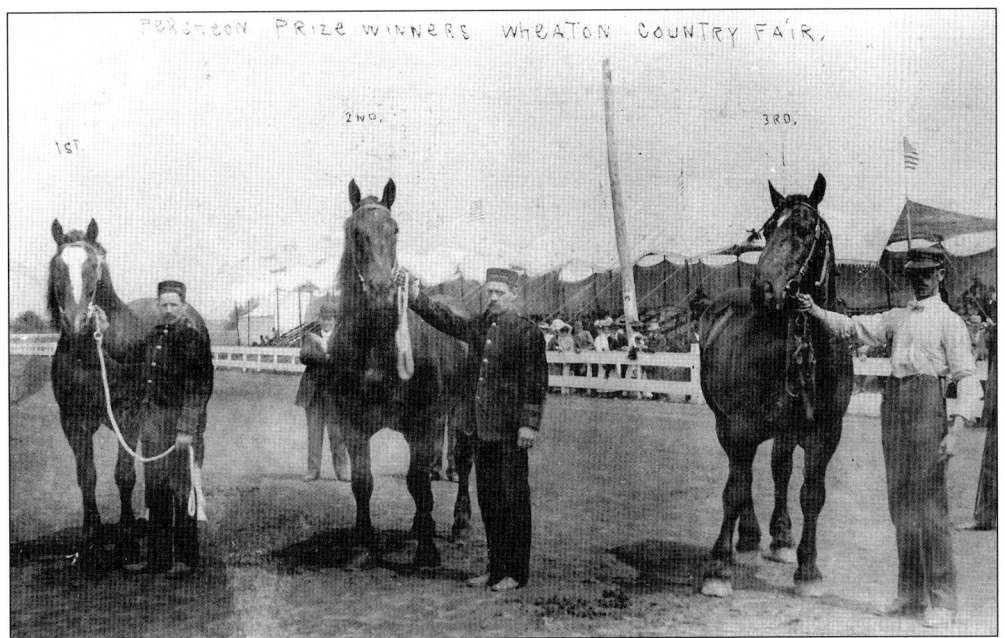

Proud owners stand on the racetrack with their Percheron first-, second-, and third-place prizewinners at the Wheaton Country Fair. These horses originated in the province of Le Perche, France, near Normandy. Thousands of Percherons were imported to the United States from the late 1800s until World War II. (Courtesy of the Wheaton Historic Preservation Council.)

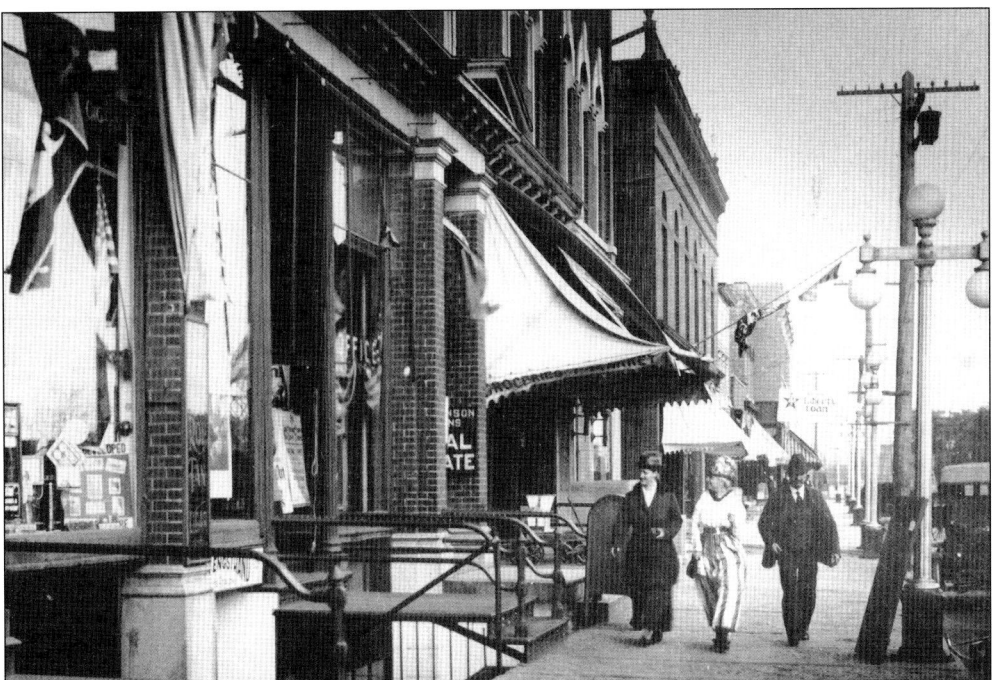

Shoppers stroll along Front Street before an array of well-stocked windows. Note the stairs leading to shops beneath street level in this c. 1900 photograph. These basement entrances are all paved over. (Courtesy of the Wheaton Historic Preservation Council.)

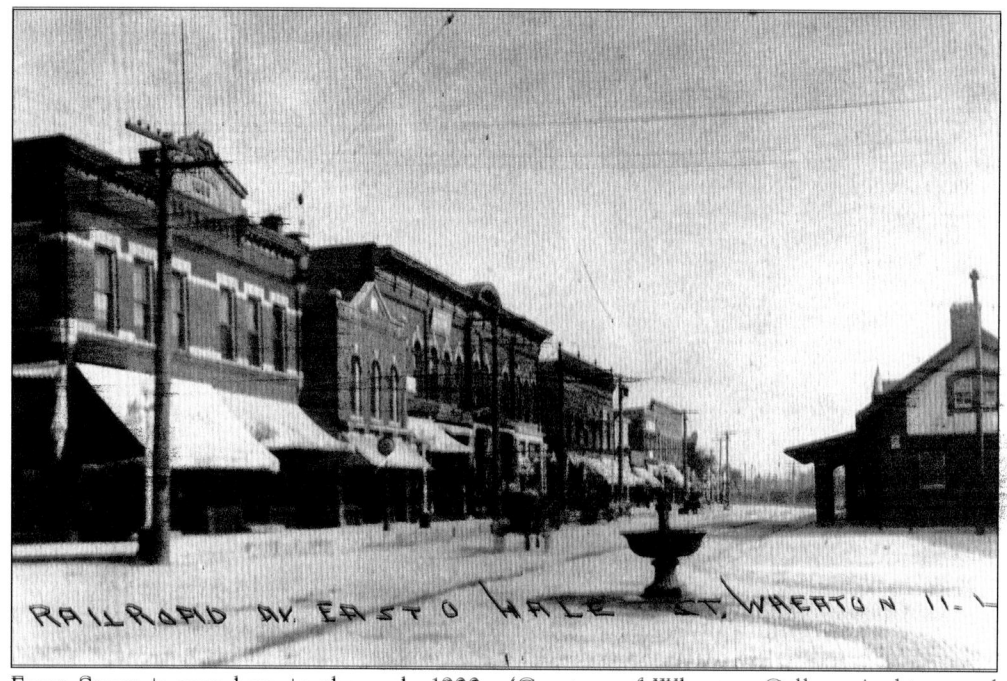

Front Street is seen here in the early 1900s. (Courtesy of Wheaton College Archives and Special Collections.)

This man pedals his bike on the dirt surface of west Front Street in 1901. The large turret, seen behind on the corner of Front and Hale Streets, was recently remodeled. A seed store stands to the far left. (Courtesy of the Wheaton Historic Preservation Council.)

Newton Matter placidly pokes his face through his newspaper, the *Wheaton Illinoisan*. The many-talented Matter bought the paper in 1889 from H. C. Paddock. The production facility was located on North Hale Street. Matter, also an alderman, coroner, supervisor, city clerk, and county treasurer, received a poem by the Honorable Frank Herrick: "An Editor with ready pen / Alert and sage / He chronicled the deeds of men / in good DuPage!" A bit of Matter's playful character is glimpsed in a report on the annual Matter family reunion and picnic, wherein "Newton Matter, editor of the *Wheaton Illinoisan*, was on the program for an address, but it seems Newt 'smelled a mice' and went fishing, for which he will not be forgiven, as everybody knew that if Newt got started he would bring down the trees by his flights of oratory." (Courtesy of the Wheaton Historic Preservation Council.)

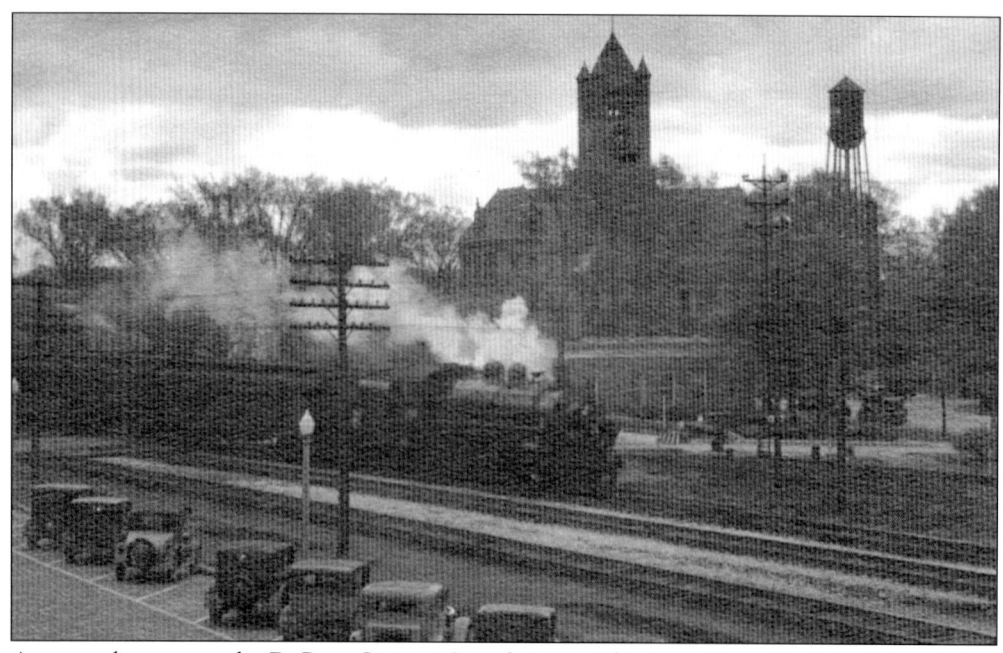

A train whizzes past the DuPage County Courthouse in the 1930s. With the Chicago, Aurora and Elgin rail yard located immediately west of the business district, Wheaton's downtown hummed with prosperous activity for many years. Sadly, the advent of outlying malls, such as Danada to the south and Stratford Square to the north, greatly drained its vitality. . . until recent years. (Courtesy of Wheaton College Archives and Special Collections.)

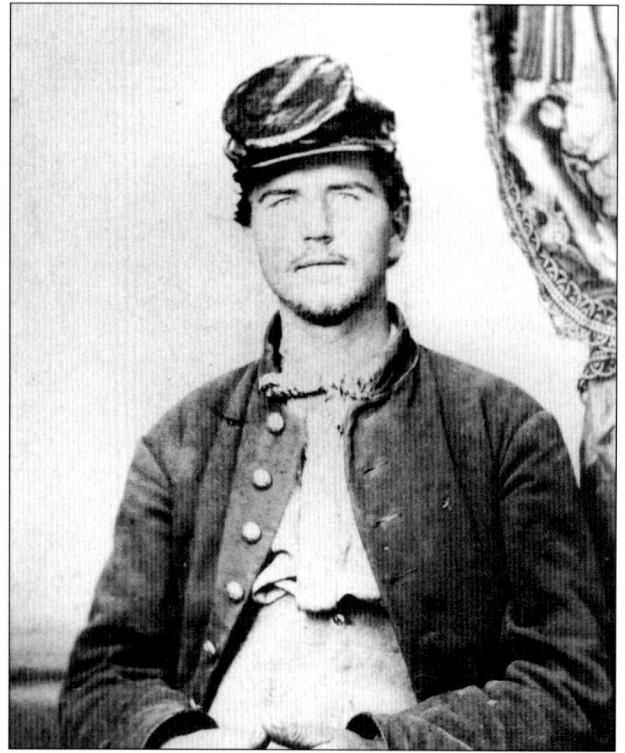

Young, trim H. D. Compton, Wheaton resident, is seen here during the War of Northern Aggression. It is inscribed as "An Easter greeting." (Courtesy of the Wheaton Historic Preservation Council.)

H. D. Compton is seen here sometime long after the war, grayer and rounder, but yet a survivor. He lived at 506 North West Street with his family. (Courtesy of the Wheaton Historic Preservation Council.)

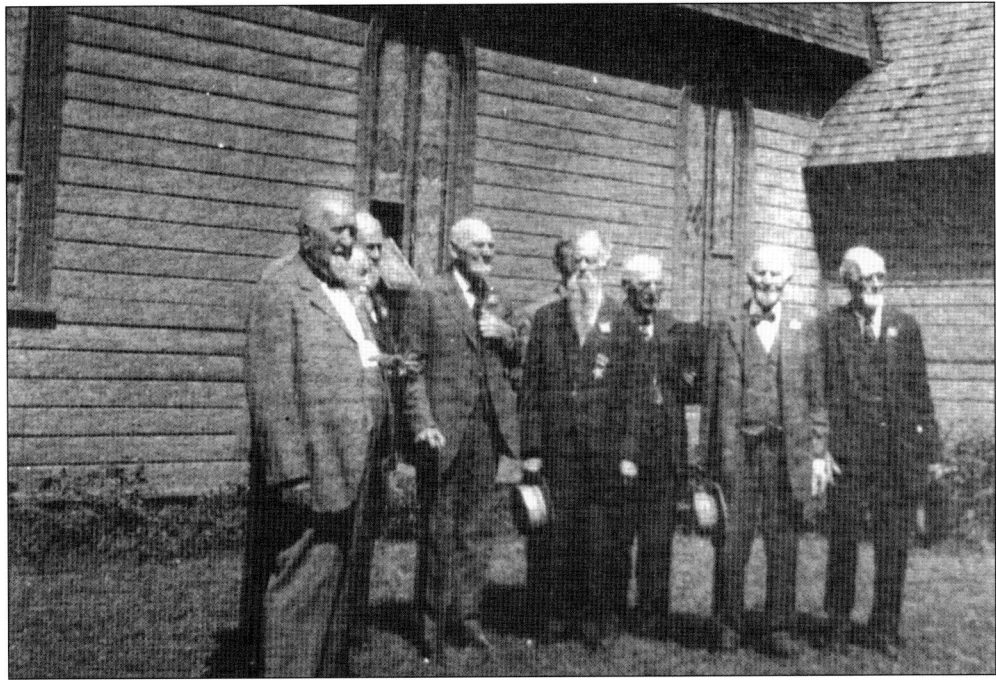

The 105th Illinois Infantry gather on the lawn of Trinity Episcopal Church in 1926 or 1927 for a luncheon reunion. H. D. Compton stands on the far left. (Courtesy of the Wheaton Historic Preservation Council.)

This graceful Italianate house was owned by Alfred Hadley Hiatt, a local druggist and Wheaton College professor of physiology and hygiene. The college eventually acquired the property for a student residence called Hiatt Hall, housing 76 girls. Razed in the 1960s, Hiatt Hall stood between Edman Chapel and Nicholas Library, now called Buswell Memorial Library. The small white house behind served as Hiatt Apartments. (Courtesy of Wheaton College Archives and Special Collections.)

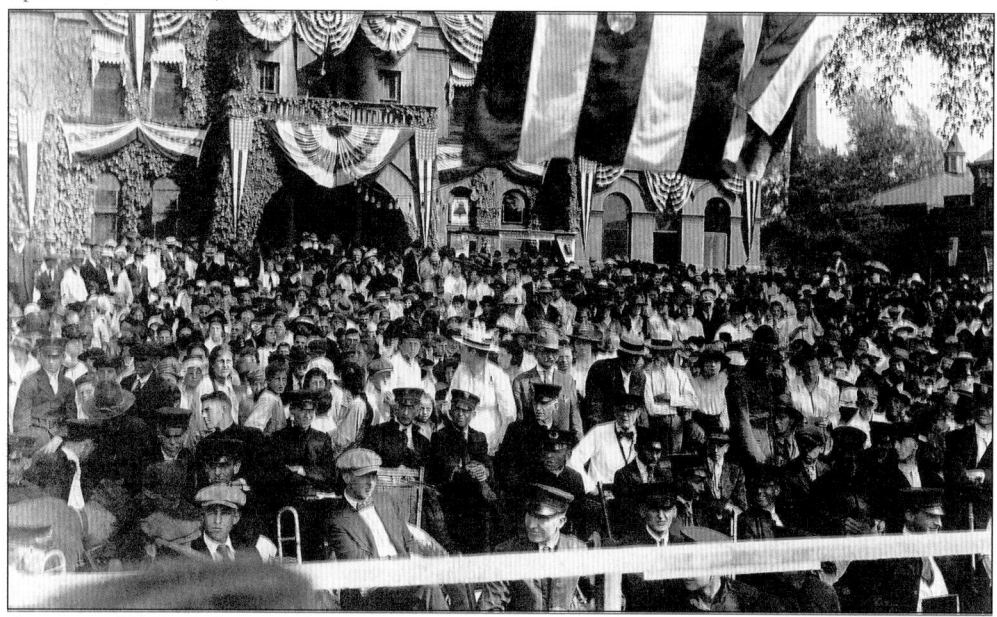

Citizens of DuPage County convene on the southern lawn of DuPage County Courthouse for a patriotic celebration in 1920. A few of the city buildings, visible to the right, are now all gone. Veterans, preachers, priests, and women in big hats turned out for the event. This photograph was taken from the platform looking out at the crowd. (Courtesy of the Wheaton Historic Preservation Council.)

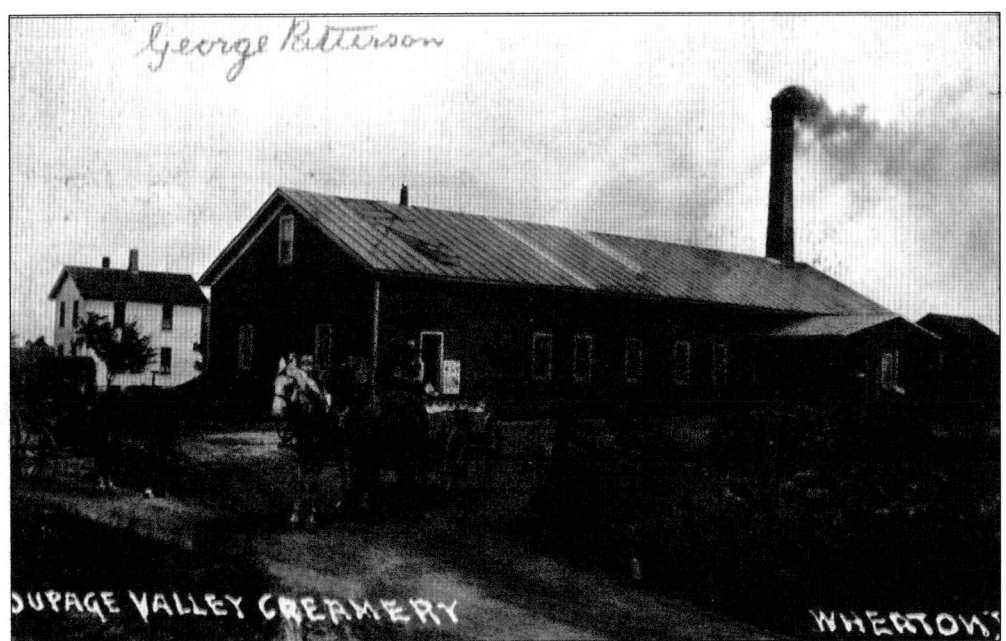

The DuPage Valley Creamery serviced the city before the days of easy refrigeration. Dairy products required quick delivery before spoiling. The driver is unidentified. (Courtesy of the Wheaton Historic Preservation Council.)

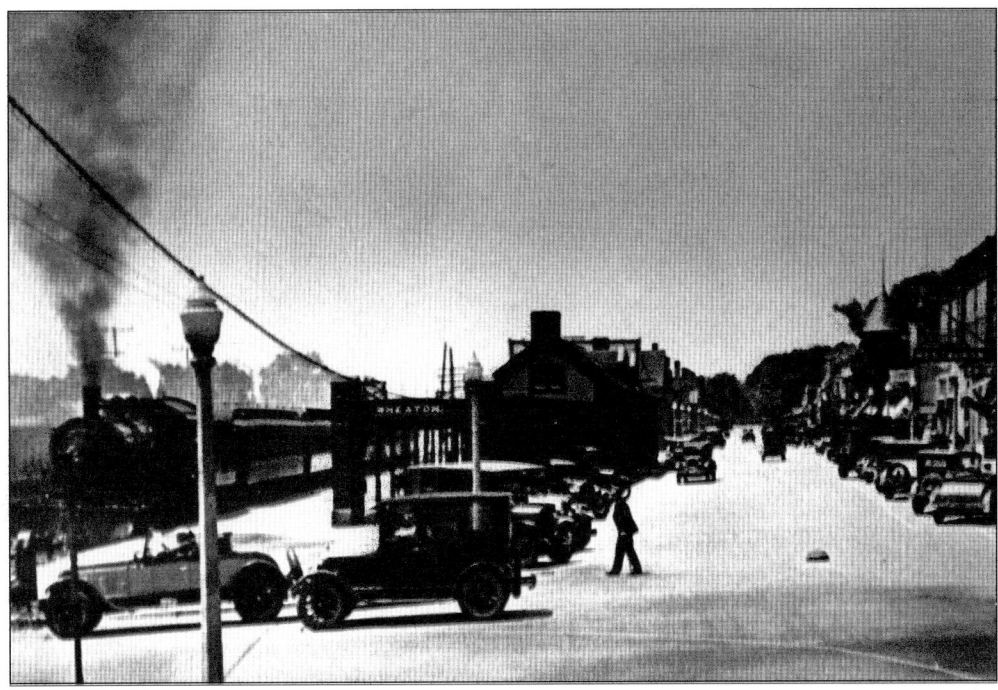

This photograph looks down Front Street at the former depot in the early 20th century. Since the station moved a block west, this quaint building has seen several businesses come and go, including a hair salon and a fruit smoothie shop. (Courtesy of the Wheaton Historic Preservation Council.)

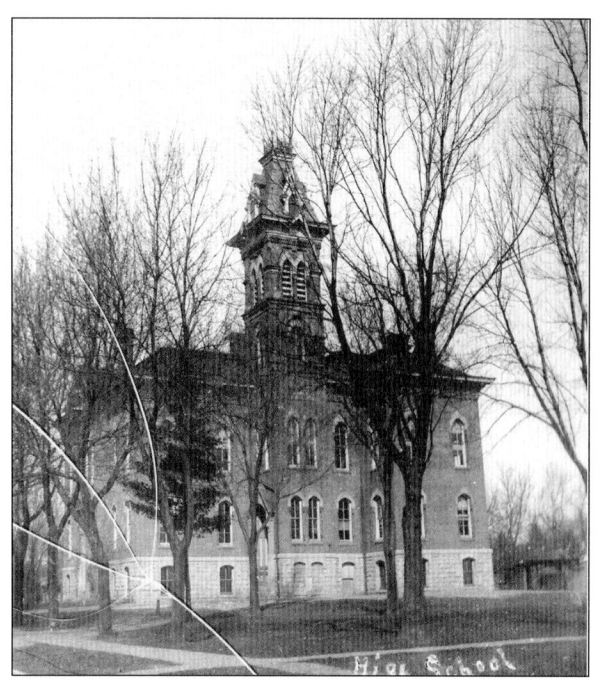

This historic structure, built around 1874 and known through the years as Central School, Longfellow, Wheaton Jr. High, and Wheaton High School, fell to the wrecking ball in 2001, replaced by a larger state-of-the-art structure. The new building was constructed next to the old, so students could watch the progression. The old property functions as a playground. (Courtesy of Wheaton College Archives and Special Collections.)

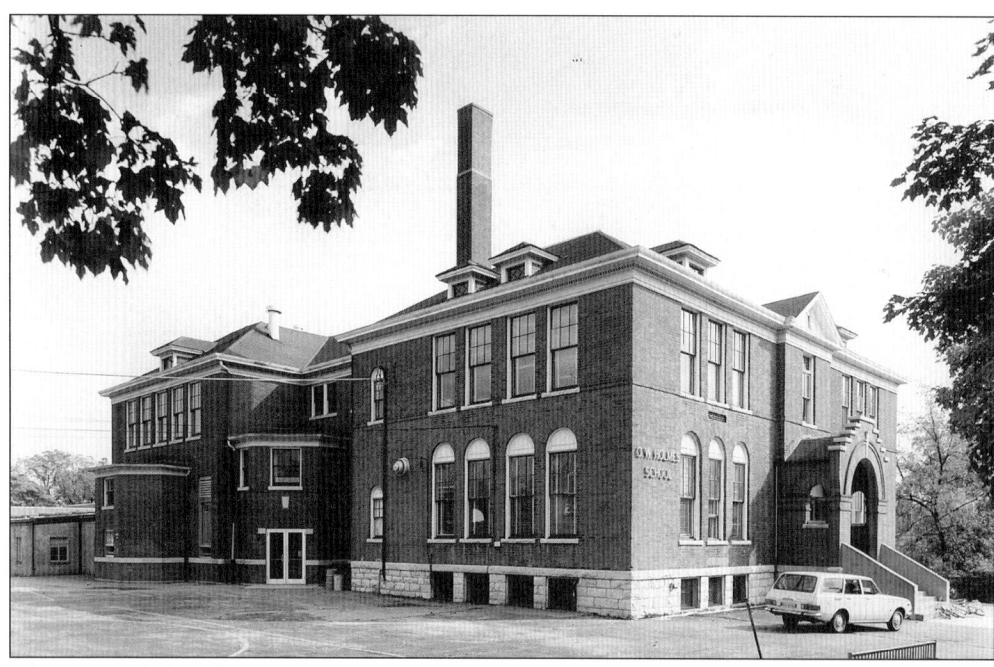

Oliver Wendell Holmes School is seen here around 1970. Also called Clifford School, the names changed in 1972 when School District 200 was formed with the merger of Wheaton and Warrenville Schools. It was built in 1894 and renovated several times to meet a growing population. (Courtesy of the Wheaton Historic Preservation Council.)

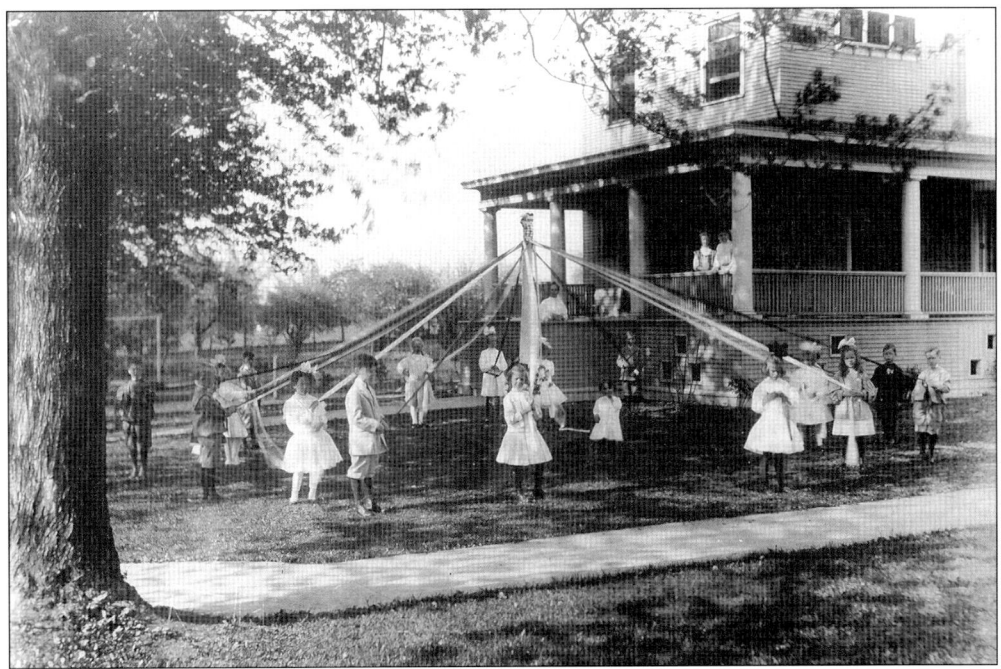

Children gather merrily around the maypole at the William Howard Monroe home at the southwest corner of Wheaton Avenue and Harrison Street in 1909. Monroe's daughter, Harriet, is celebrating her ninth birthday. (Courtesy of the Wheaton Historic Preservation Council.)

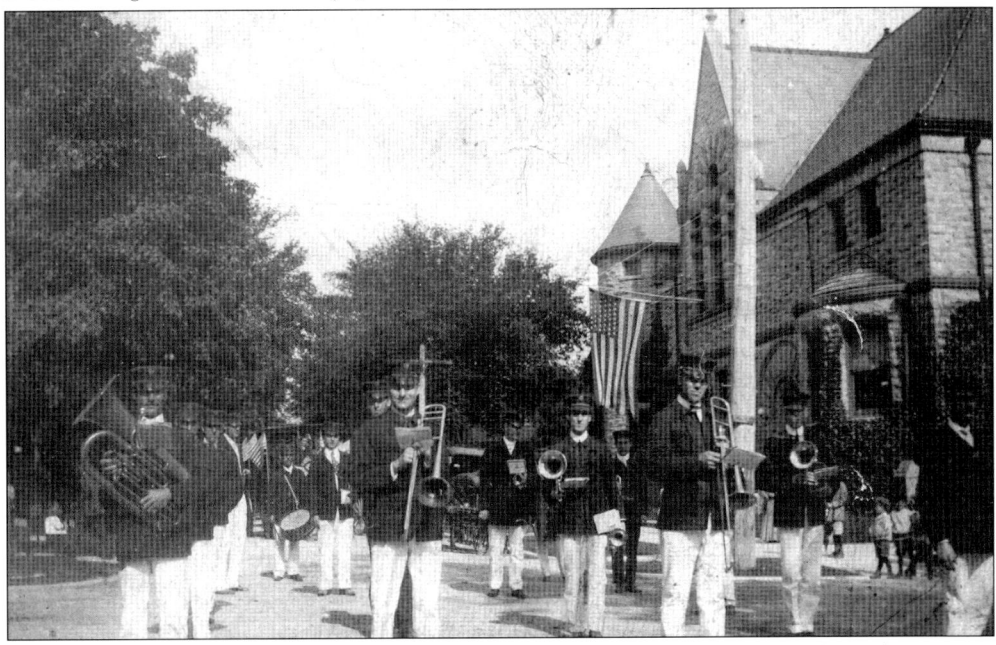

Adams Library is seen behind the marching band at the corner of Main and Wesley Streets. Built with funds donated by John Quincy Adams, it was used for plays and other civic events. Adams also donated money to Wheaton College for the construction of a women's dormitory and the gymnasium, called Adams Hall. This building now houses the DuPage County Historical Museum. (Courtesy of the Wheaton Historic Preservation Council.)

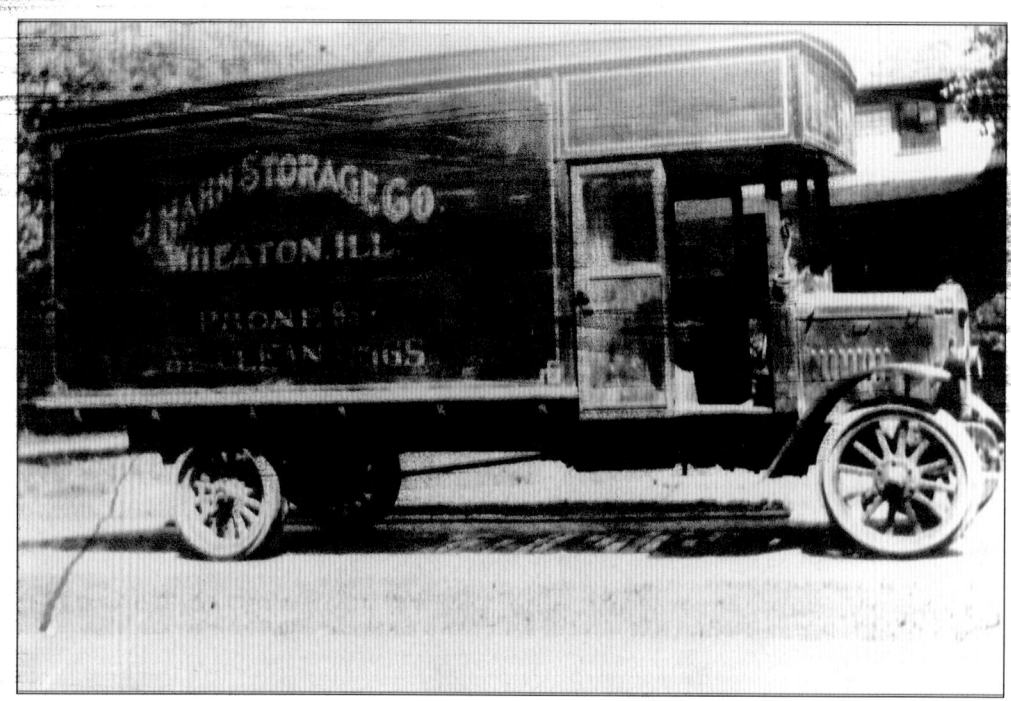
The Hahn Storage and Warehouse Company also cleaned rugs. (Courtesy of the Wheaton Historic Preservation Council.)

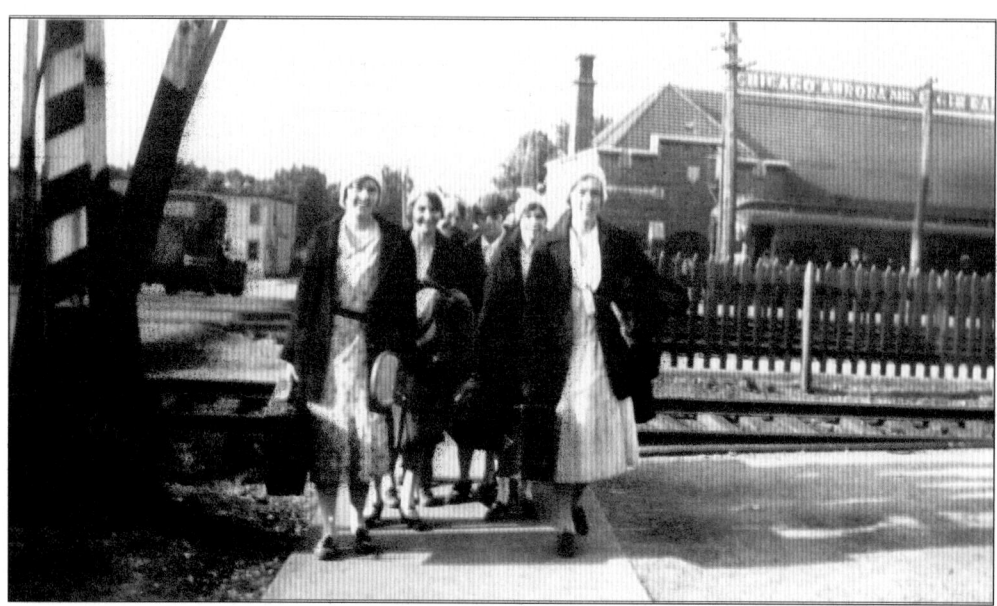
These young ladies, probably Wheaton College students returning from a tennis tournament or vacation, depart with their luggage from the Chicago, Aurora and Elgin station, seen behind. Built in 1911, the structure was one of the handsomest on the line, solidly constructed in anticipation of much usage. This photograph is from the 1920s. (Courtesy of Wheaton College Archives and Special Collections.)

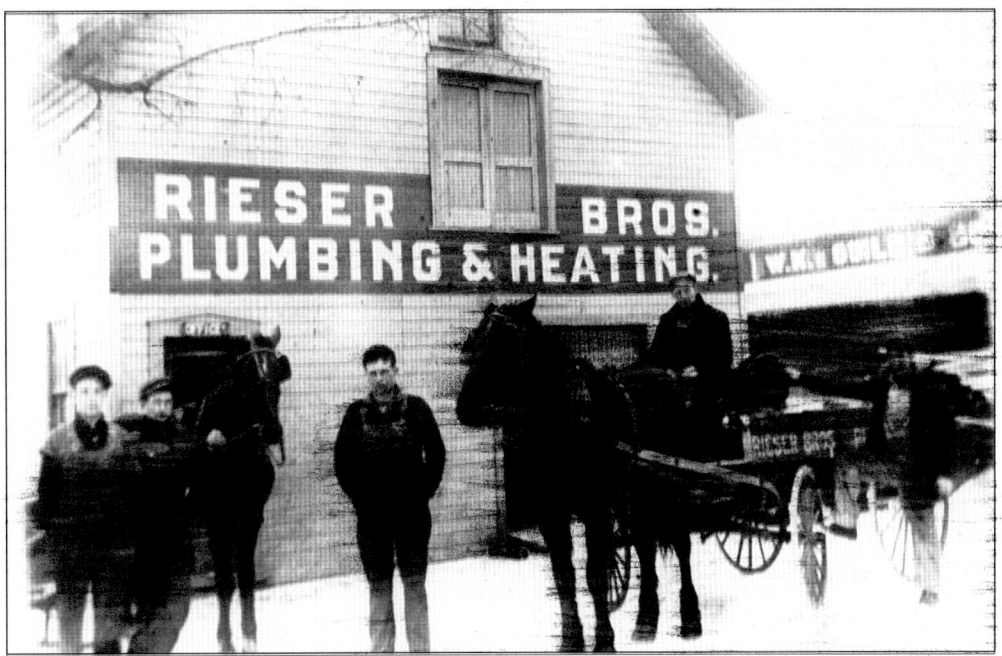
Employees of Rieser Brothers Plumbing and Heating pose for this 1900 photograph. Considering the evident snow, they no doubt enjoyed brisk business that winter. From left to right are unidentified, Edward Wiesbrock, Herman Rieser, Ben Rieser, and Joe Rieser. (Courtesy of the Wheaton Historic Preservation Council.)

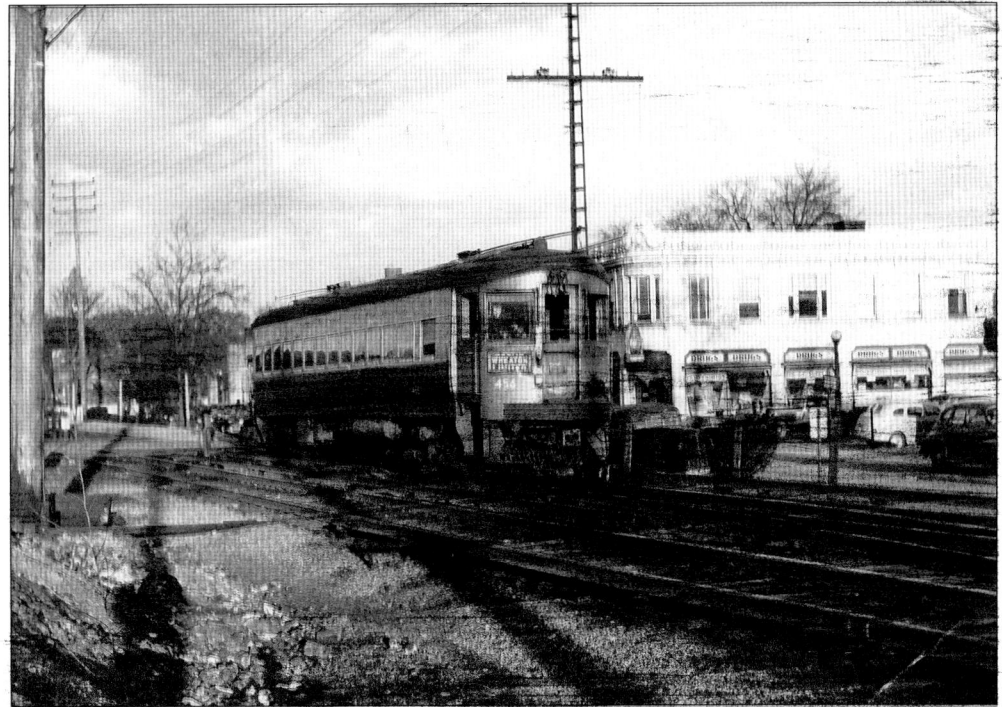
A Wheaton limited-passenger car is parked on the rails, mid-1940s. (Courtesy of the Wheaton Historic Preservation Council.)

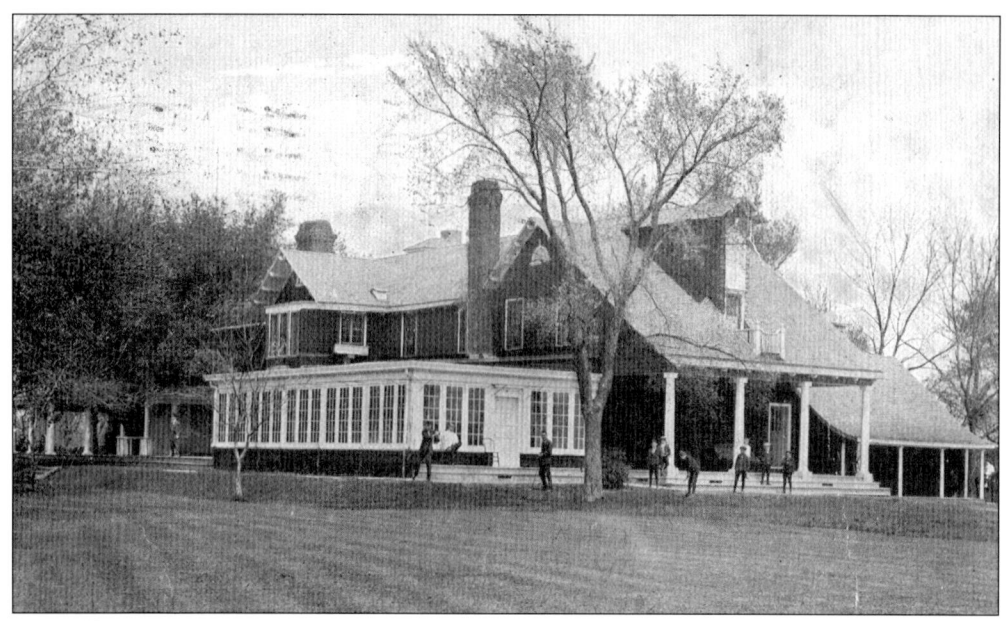

Men of leisure practice their swings at the Chicago Golf Club in this c. 1910 postcard. Founded by architect Charles Blair McDonald in 1893, the club has hosted world-class tournaments and golfers, including Bobby Jones. Abraham Lincoln's son, Robert Todd Lincoln, served as the club's president in 1905–1906. (Courtesy of the Wheaton Historic Preservation Council.)

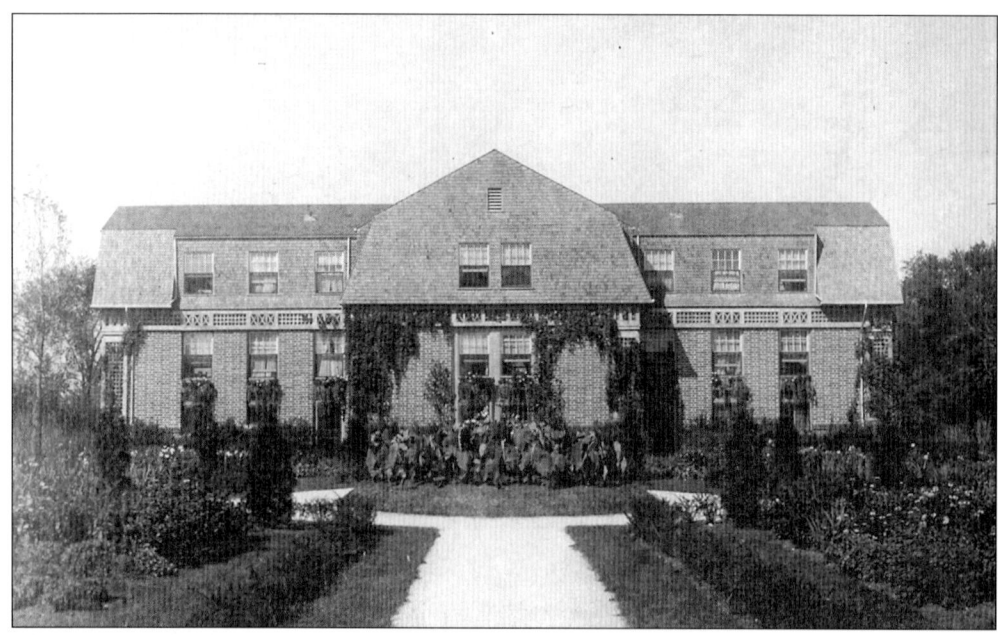

This photograph shows a private cottage from the Chicago Gold Club, reserved for summer guests. The land was chosen to accommodate the suburban homes of the club's wealthy clientele. It is located on 180 acres near Warrenville Road. (Courtesy of Wheaton College Archives and Special Collections.)

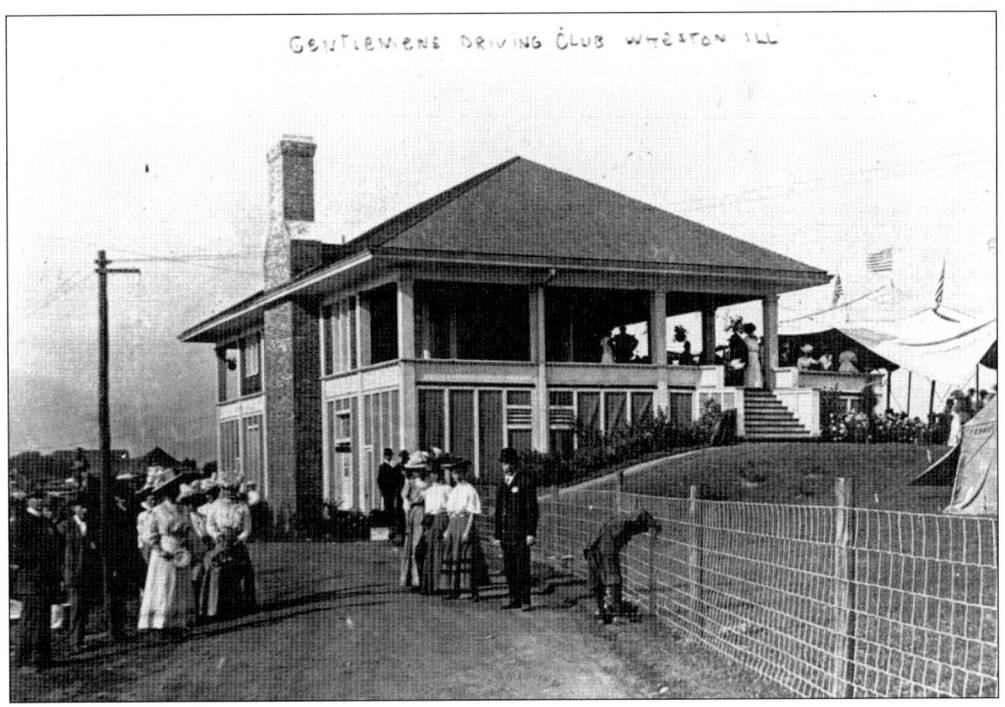
The Gentleman's Driving Club, located on the corner of Geneva Road and Main Street, provided open-air entertainment for Wheaton's elite. (Courtesy of the Wheaton Historic Preservation Council.)

The water-pumping station is seen in the foreground of this c. 1900 photograph; behind is the DuPage County Courthouse. (Courtesy of the Wheaton Historic Preservation Council.)
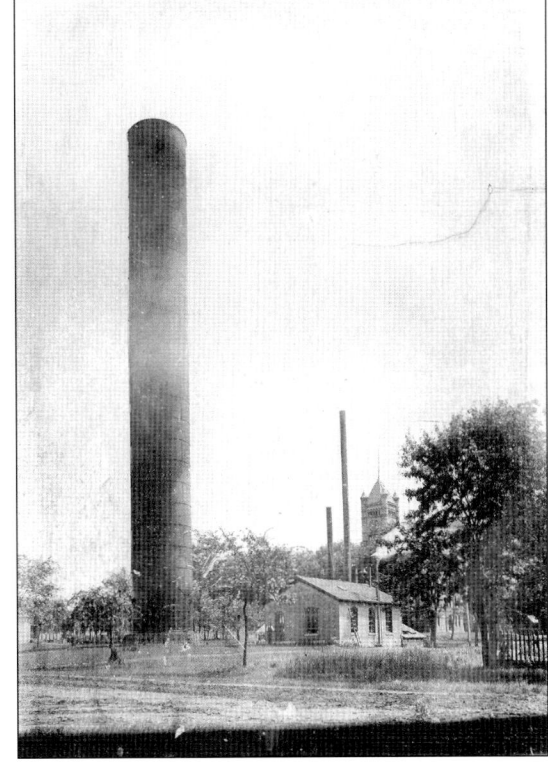

Frank Earl Herrick (1875–1967), judge and former police magistrate, earned the title of "Wheaton's Poet Laureate," composing poems seemingly about everything and everybody in his sight. Among his multitudinous chapbooks are pieces dedicated to roses, firemen, friendship, Prohibition, local churches, trains, winter, autumn, rain, America, Billy Graham, Red Grange, Illinois, and a host of city clerks, attorneys, pastors, and residents—2,000 poems altogether. Herrick's hardcover anthologies were produced by the Brethren Press of Elgin, Illinois, an Evangelical publisher. Among his books are *Poems of DuPage County*, *Prohibition Poems*, and *Lays of Outdoor Wheaton*. An 1899 graduate of Wheaton College, his work serves as a pietistic, poetic history of the city and DuPage County, a heartwarming reminder of a simpler day. Those citizens who were honored with a verse by the discerning Judge Herrick were fortunate indeed.

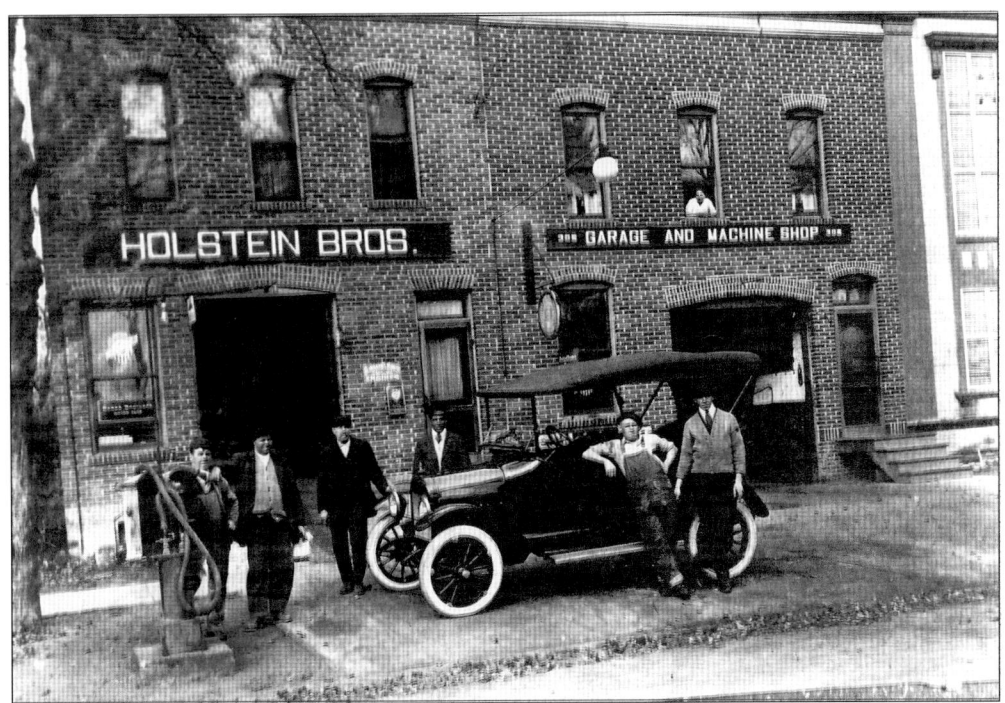
Holstein Brothers Garage and Machine Shop at 312 Front Street is seen here in 1917. (Courtesy of the Wheaton Historic Preservation Council.)

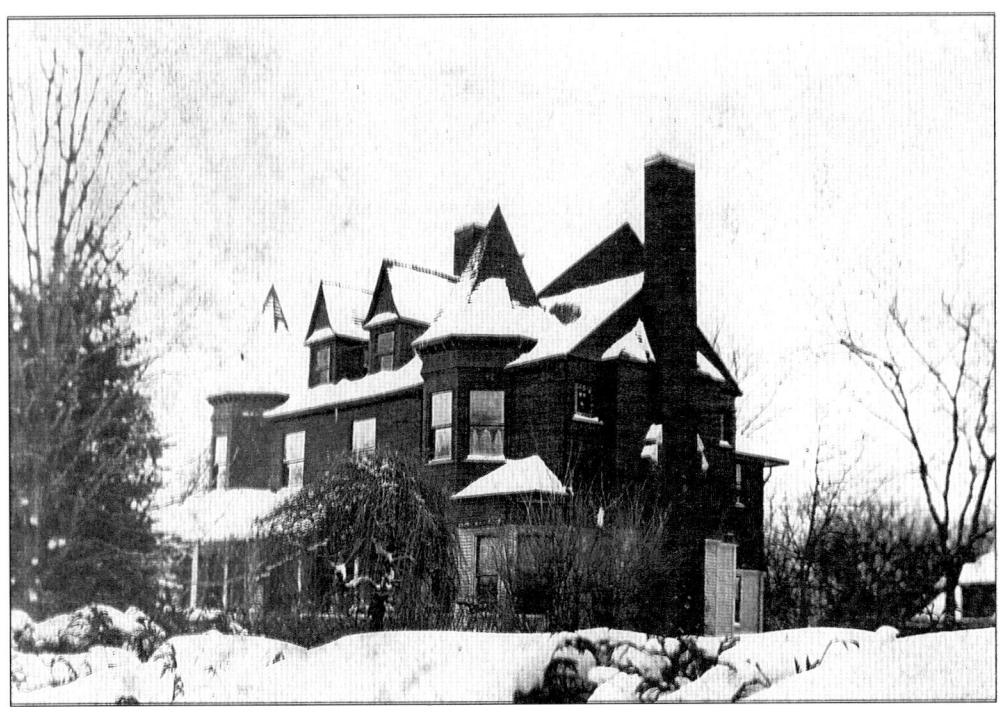
This majestic old house stands at 512 Scott Street. (Courtesy of the Wheaton Historic Preservation Council.)

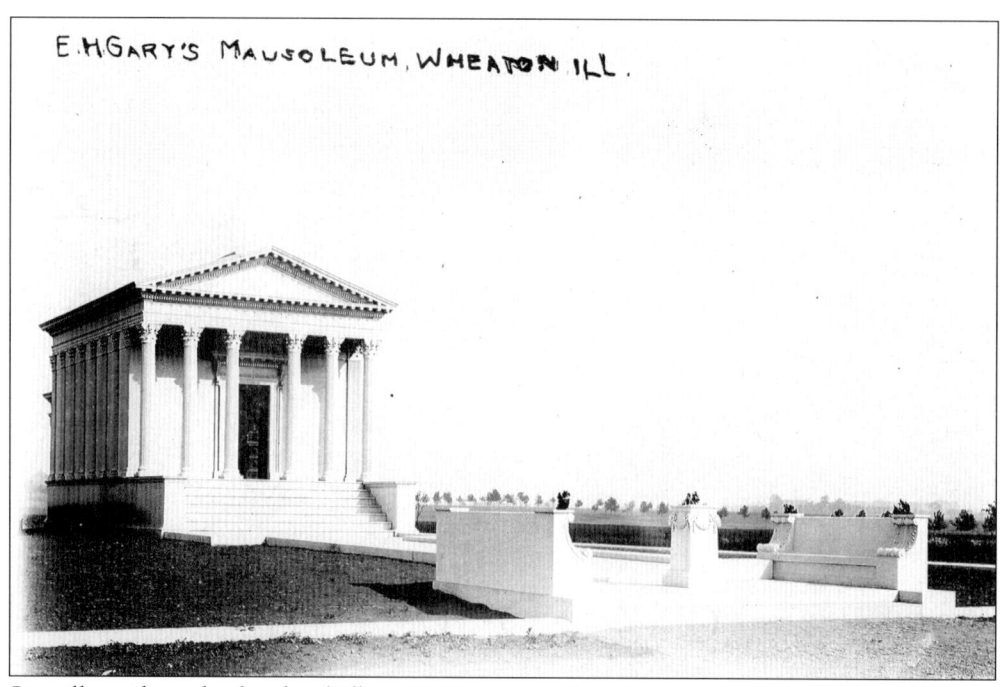

Six pillars adorn the façade of Elbert H. Gary's temple-style mausoleum, located at Wheaton Cemetery. He is buried beside his first wife, Julia Graves Gary. Elbert was president of U.S. Steel. (Courtesy of the Wheaton Historic Preservation Council.)

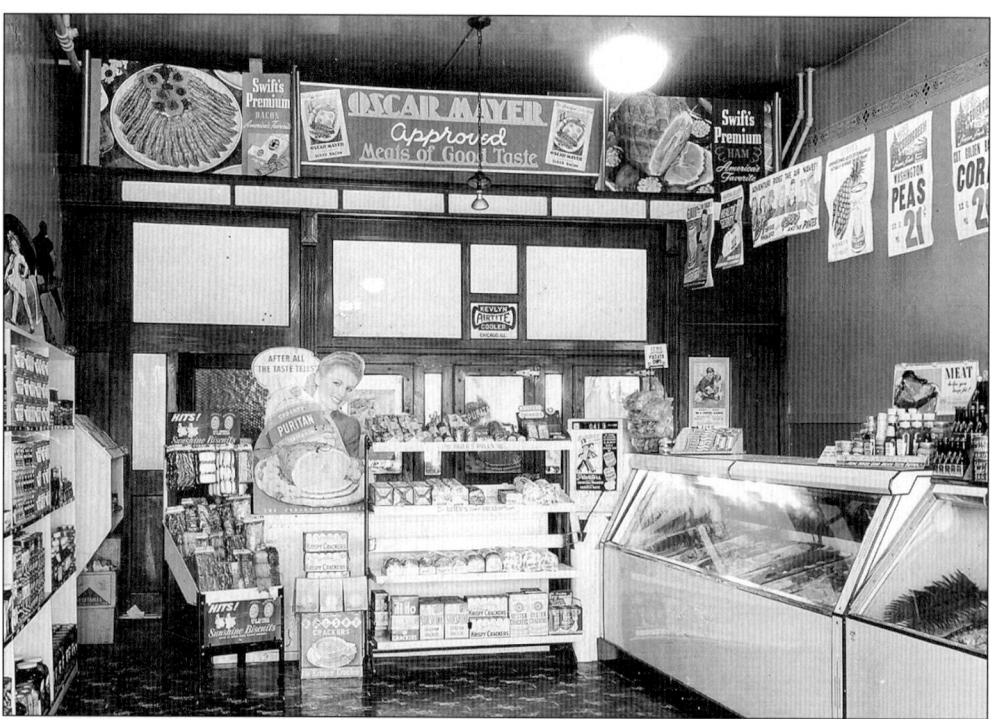

Sundries displayed in a local grocery in the 1940s are seen here. (Courtesy of Wheaton College Archives and Special Collection.)

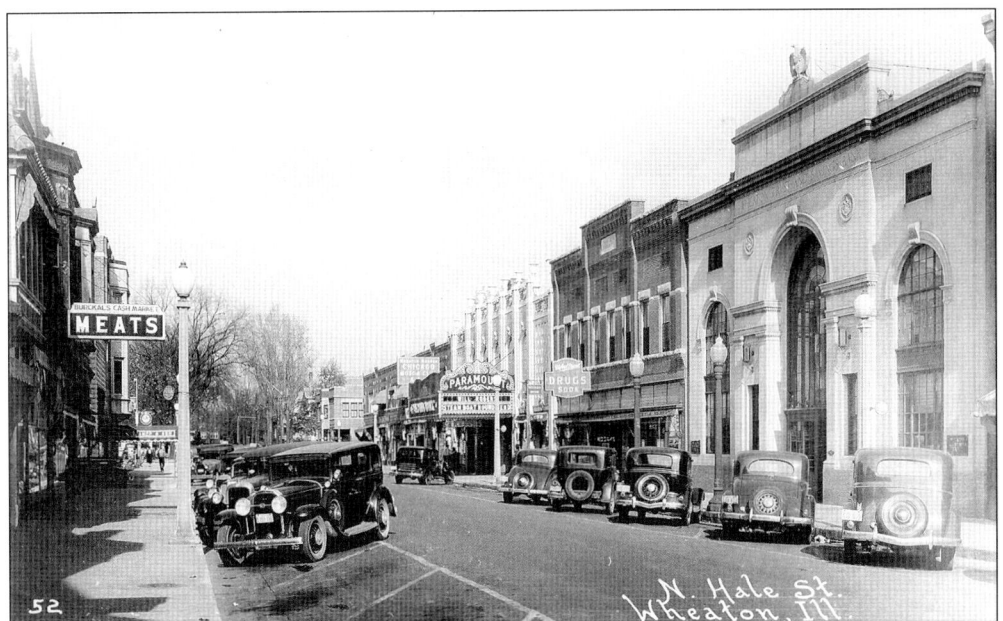

This photograph is looking south from Wesley and Hale Streets in the early 1920s. The Wheaton Grand Theater is showing a Will Rogers film. Until the outlying malls drained the downtown businesses, Hale Street buzzed with prosperous activity, full of bakeries, banks, and clothiers. Receiving renewed attention from city planners, the downtown has enjoyed a definite comeback. (Courtesy of the Wheaton Historic Preservation Council.)

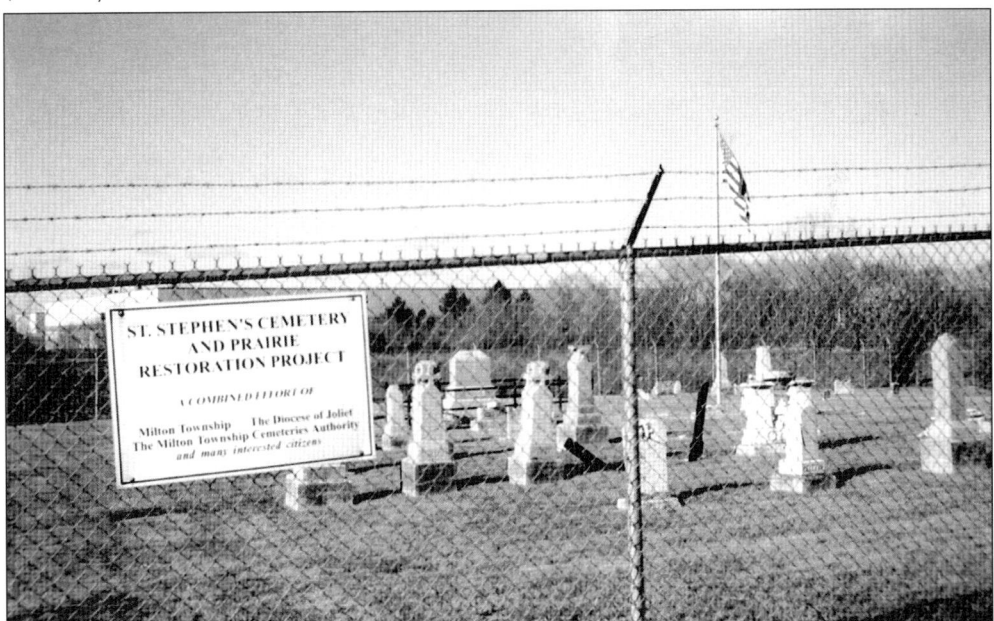

This little graveyard is all that remains of Gretna, a "lost" village on St. Charles Road, two miles north of Wheaton. St. Stephen's Church was built here in 1852, serving a small Catholic community. Gretna promised to blossom until Wheaton's railroad pulled its business away. The final services were conducted in the 1890s, and the last burial occurred in 1911. It is tucked behind an industrial park, accessible only by footpath.

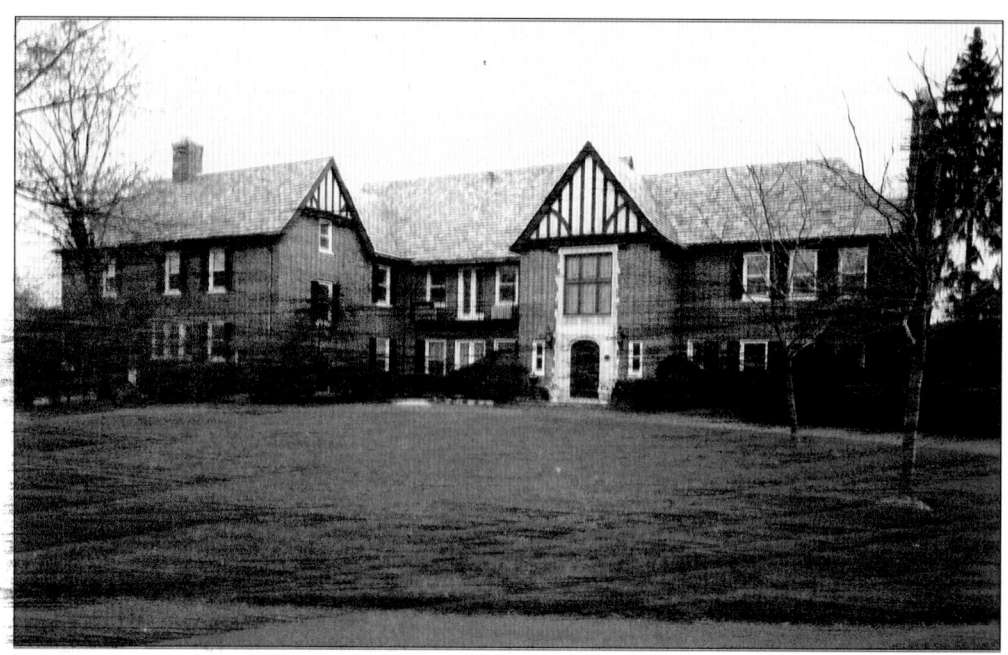

Another fine residence is the former Edward Nash Hurley Jr. Home, constructed in 1928. Central Wheaton boasts several such palatial estates, recalling the days when Chicago's businessmen lived far from the madding crowd in the peaceful suburbs. (Courtesy of the Wheaton Historic Preservation Council.)

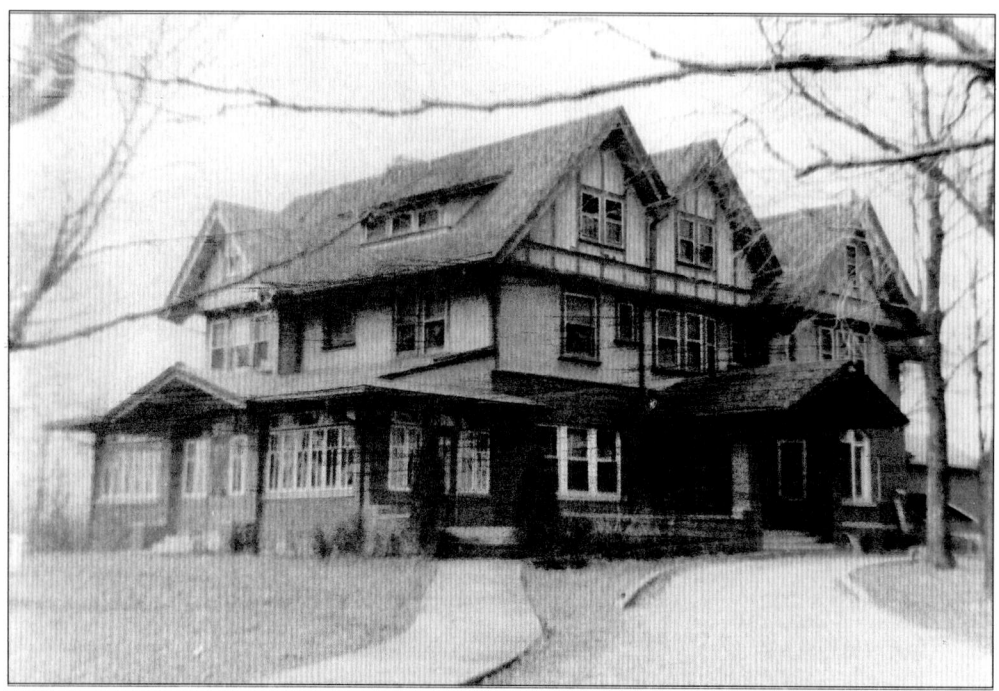

The George Plamondon residence, at an unknown date, is seen in this photograph. Beginning in 1938, it was used by Midwest Military Academy. (Courtesy of the Wheaton Historic Preservation Council.)

This advertisement profiles rural property in northern Wheaton. The barn is gone and the field is covered with malls and restaurants, but the old house stands, serving as a shelter for battered women. (Courtesy of the Wheaton Historic Preservation Council.)

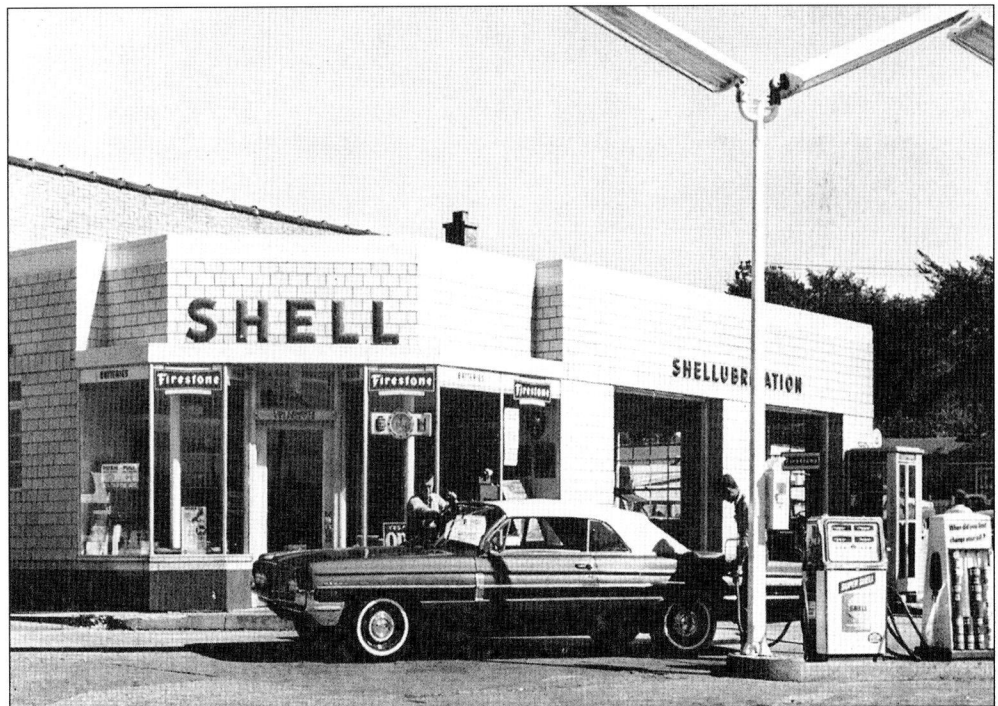

The Shell Station is seen here in the early 1950s. Here one's car received an efficient "Shellubrication." (Courtesy of Wheaton College Archives and Special Collections.)

The Wheaton Municipal Building, on the south side of Wesley Street, housed the mayor, city clerks, and aldermen, with room for 36 chairs to accommodate a public audience. This building was razed when the office moved to 303 West Wesley Street, creating space for a parking lot. (Courtesy of the Wheaton Historic Preservation Council.)

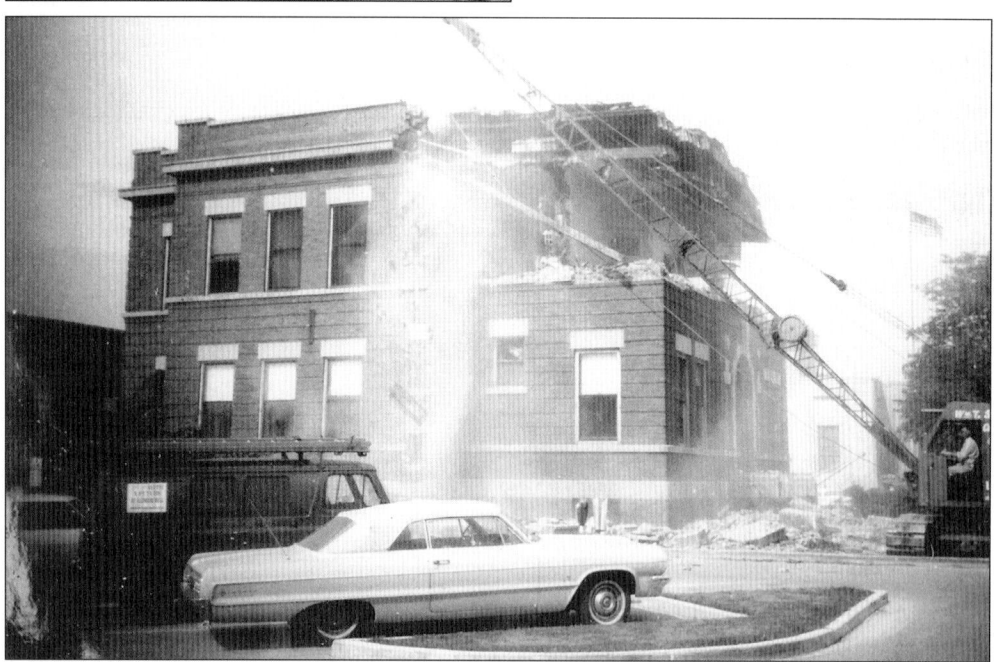

The Wheaton Municipal Building falls to the wrecking ball. The new city hall stands on property formerly occupied by the home of Mayor Marion J. Pittsford. Before the new structure was bought by the City, it housed the Suburban Casualty Company. Much remodeled, it stands across the street from the post office. (Courtesy of the Wheaton Historic Preservation Council.)

The DuPage County Courthouse is seen in its glory, sometime in the 1950s. This 1896 building replaced the original courthouse, which was built in 1868 on property bought from Warren L. Wheaton. In 1959, an annex was added after many smaller buildings surrounding the courthouse were demolished. In the early 1970s, a jail and county administration complex opened on County Farm Road. This property was sold to National-Louis University, which opened its Wheaton campus in 1993.

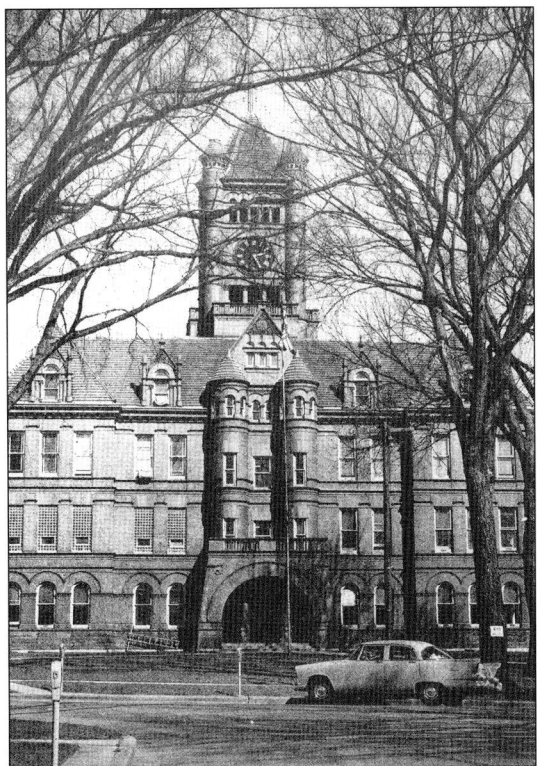

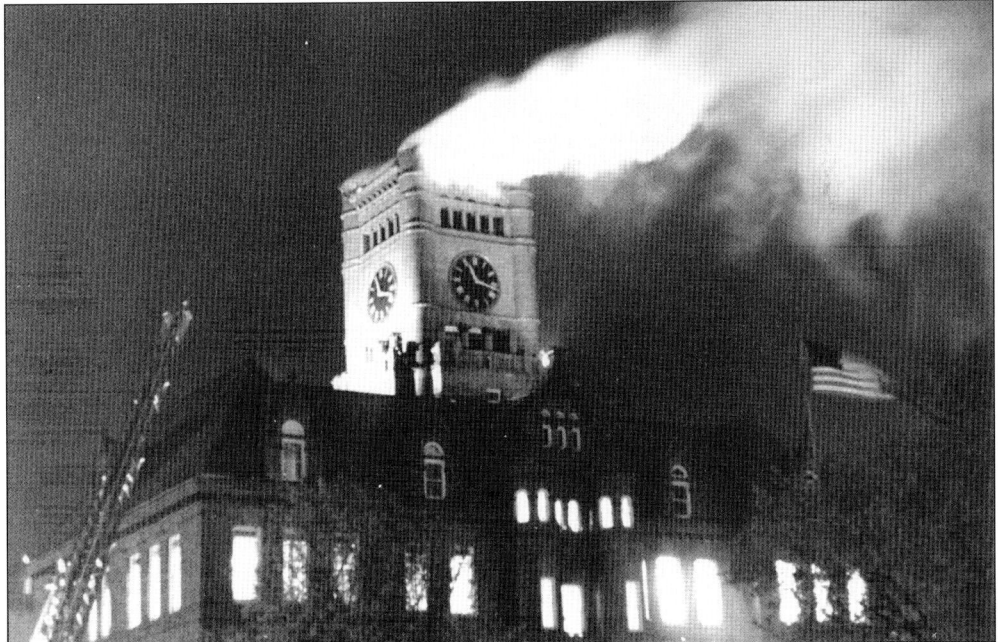

The DuPage County Courthouse occasionally attracts Mother Nature in addition to lawyers, judges, and clerks. Here the blasted bell tower burns after a 1988 lightning strike. The streets below were cordoned off while the tower was reconstructed. (Courtesy of the Wheaton Historic Preservation Council.)

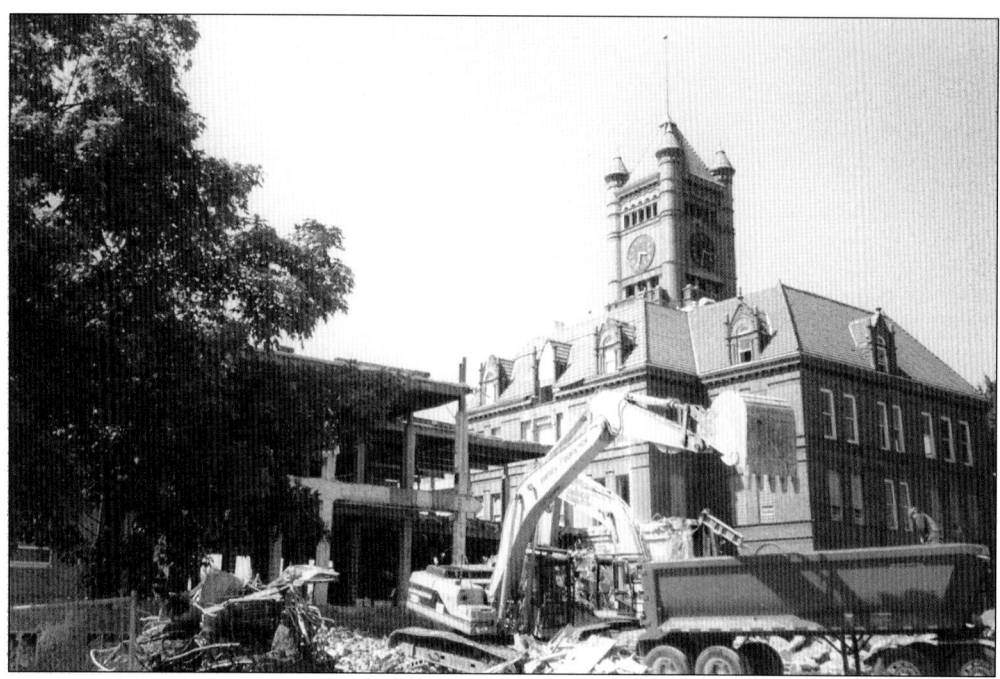

In late 2005, bulldozers tear into the 1959 jailhouse annex, skillfully isolating the original 1896 courthouse, which is to be luxuriously remodeled as condominiums, with townhomes surrounding it. The eastern wall is exposed for the first time in decades.

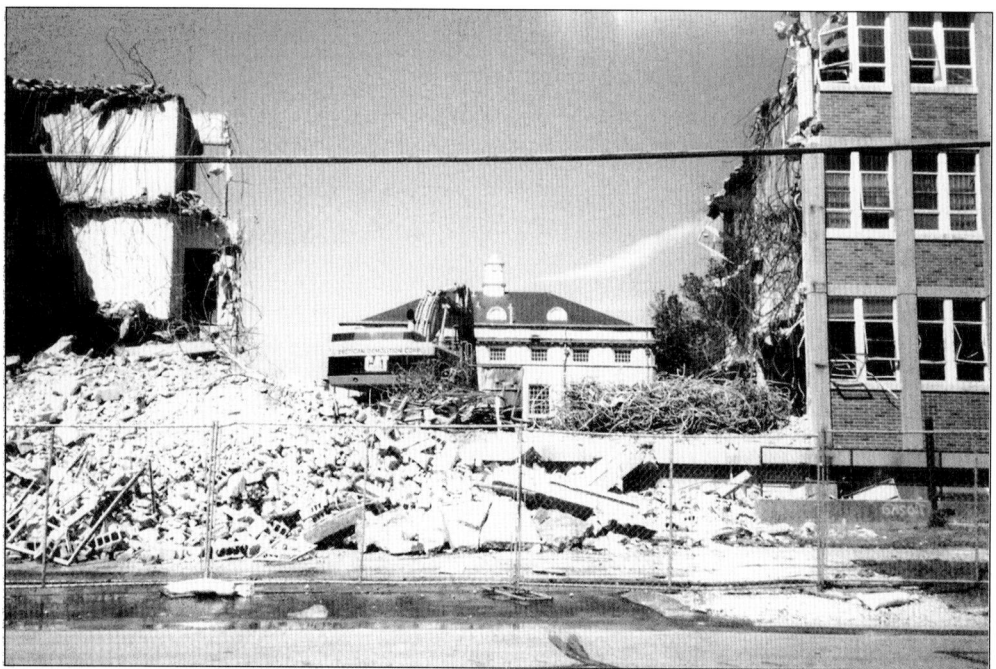

Once upon a time, inmates idly dreamt of watching a wrecking ball suddenly swing into the thick concrete walls of DuPage County Jail, releasing their confines to the fresh air and freedom. Alas, the getaway is here available, but the prisoners are gone. The older, freestanding annex is seen just beyond the rubble. It, too, was set to be remodeled in 2006.

Two

WHEATON COLLEGE

Mel Larson writes in *Young Man on Fire* (1945), "Wheaton College nestles quietly on the fringe of the town of Wheaton, Illinois. . . . It has been turning out Christian leaders since 1860 and today ranks as one of the best Christian colleges on the North American continent. Ever since its beginning it has adhered strictly to the fundamental truths of the Bible and its value and reputation is such that it is clearly one of the top interdenominational schools of our land and accepted and revered by those many denominational groups." He goes on: "Were you to pause on a quiet afternoon or early evening stroll through the campus and think of the many Christian leaders who received their college training on these grounds you would be amazed." Though no longer on the fringe of the city, Wheaton College is still ranked as one of America's Top 100 National Liberal Arts Colleges. The undergraduate population averages 2,400, and the graduate population averages 400, with representation from 47 countries. The most enrolled majors are English, business, music, communications, and psychology. Pictured is the late Dr. V. Raymond Edman, fourth president, standing before an inscription stating the college's motto: "For Christ and His Kingdom." (Courtesy of Wheaton College Archives and Special Collections.)

Jonathan Blanchard, founder and first president of Wheaton College, was born in Rockingham, Vermont, in 1811. He attended Middlebury College, where he joined the Congregational Church, there choosing to pursue the ministry. After that he attended Andover Theological Seminary, where he met Theodore Weld, the anti-slavery crusader. Blanchard embraced the cause and joined the Anti-Slavery Society as a lecturer. After marrying Mary Bent in 1838, he accepted the pastorate of Sixth Presbyterian Church in Cincinnati and was ordained at a ceremony preached by Lyman Beecher. In 1845, Blanchard accepted a call to the presidency of Knox College in Galesburg. He performed successfully, pulling the institution out of debt; however, his clashes with Knox's cantankerous founder, George Gale, facilitated his resignation in 1859. Blanchard took the pastorate of First Congregational Church, there reviewing invitations from various colleges. One of the more attractive proposals was from Illinois Institute, a preparatory school founded by the Wesleyans in 1853. This he accepted. One of Blanchard's pressing pedagogical ambitions was to include African Americans in the school, a radically progressive program for the day. Resilient and visionary, he was also kind, exactly right for the rigors of frontier education. By any standard, Jonathan Blanchard was a towering Christian and an American hero. (Courtesy of Wheaton College Archives and Special Collections.)

This sketch portrays the main building and gentlemen's housing for the Illinois Institute in 1861. The building on the right is the central structure for Blanchard Hall. For many years, cows and sheep roamed the property without interference. (Courtesy of Wheaton College Archives and Special Collections.)

Blanchard Hall, not finished in 1873, stands alone on the windswept hill. In the next several years, additions would be constructed on either side of the central structure, expanding its capacity for offices, dormitories, a library, a chapel, and classrooms. The limestone superstructure was quarried in nearby Batavia, Illinois. The fourth floor served for many years as the men's dormitory. (Courtesy of Wheaton College Archives and Special Collections.)

William T. Osborne, the second black graduate of Wheaton College, was a freed slave from Alabama who moved to Illinois with the aid of Jonathan Blanchard and other abolitionists. After attending Wheaton College, Osborne received his ordination and moved to pastorates in Washington, Montana, Louisiana, Missouri, and Nebraska. He died in 1932 in Kansas City at age 77. (Courtesy of Wheaton College Archives and Special Collections.)

Williston Hall, also known as the Red Castle, was dedicated in 1895. First called the Women's Building, it was renamed in honor of J. P. Williston, benefactor and inventor of indelible ink. It was here that Ruth Bell first laid eyes on her future husband, William Franklin (Billy) Graham, spying him playing chess. Note the windmill. (Courtesy of Wheaton College Archives and Special Collections.)

Female students wearing uniforms converse in the lobby of Williston Hall. Note the stern but fatherly portrait of Jonathan Blanchard displayed on the landing. Shortly before Williston was built, the 1893–1894 *Annual Register* looked soberly ahead to its construction: "Those who furnish [it] will be serving not this time and nation alone but all time to come and all nations of earth." (Courtesy of Wheaton College Archives and Special Collections.)

From 1860 to 1925, the college chapel was located in Blanchard Hall. The school's president and other visiting speakers, such as pastors and missionaries, addressed the student body in this room called Fisher Hall, named after early benefactors of the college. Here the chapel is decorated for a patriotic celebration in 1902, displaying portraits of U.S. presidents and draped with bunting. (Courtesy of Wheaton College Archives and Special Collections.)

41

Charles A. Blanchard, Jonathan's son, proved to be a worthy successor to his father. Edward Coray writes in *The Wheaton I Remember*, "I will always be thankful that I knew and studied under President Charles Blanchard. No one could know the man without having his life touched . . .When Dr. Blanchard prayed it was as a son talking to a loving and beloved Heavenly Father. He thanked God for all His mercies and precious gifts . . . and prayed that each student would be kept pure, clean and strong . . . " An equally laudatory word is offered by novelist James Wesley Ingles, fictionalizing Blanchard as "Charles A. Brainerd" in *The Amazing D. Randall MacRae*: "Before the call to fill his father's chair as president, he had taught for 12 years in the same school. . . . As he arose, MacRae took in rapidly the striking characteristics of the man. He was dressed in simple black, with a black bow tie knotted loosely at the starched white collar. [MacRae] thought he had never seen a more finely shaped head. . . . The large, deep eyes were surrounded by numberless little wrinkles that were never formed by frowns but by smiles. . . . A white mustache hid the upper lip, but the strong firmness of the lower was visible." Blanchard died in 1925. (Courtesy of Wheaton College Archives and Special Collections.)

Charles's first wife, Margaret Ellen, died from heart lesions in 1884. Two years later, he married the college's dean of women, Amanda Jennie Carothers, who died in 1894. Her sister, Francis, was a graduate of the college and a medical doctor, and proved quite suitable for marriage. Here, Charles sits happily with this third and final wife, Dr. Francis Carothers Blanchard. (Courtesy of Wheaton College Archives and Special Collections.)

Pres. Charles Blanchard, bedecked in a crumpled white suit, glowers at the camera in the early 1920s. This photograph, taken at a Christian and Missionary Alliance conference, catches him at a weary moment. A powerful speaker with a commanding presence, he was in great demand on the church and college lecture circuit. (Courtesy Wheaton College Archives and Special Collections.)

43

James Wesley Ingles's warm-hearted *The Amazing D. Randall MacRae*, originally entitled *The Silver Trumpet*, tells of a talented Princeton jock who reluctantly transfers to Wheaton College in the 1920s to pursue a young lady he spotted at an evangelistic crusade in New York City. MacRae commences his search for the mysterious beauty: "[He] . . . leafed through a college directory, to the 'W' Section. Wellesley, Wesleyan, Westminster—ah, there it was! Wheaton! But to his astonishment there were two schools by the same name. One Wheaton College was a girl's school in New England. The other was almost as bad—a small coeducational school a few miles west of Chicago . . . " After writing for a catalogue, MacRae realizes that certain challenges lay ahead. "The buildings looked pitifully poor against Princeton's Gothic beauty. One particular paragraph claimed his amused attention. It read: *All students are required to abstain from practices which tend to the wasting of time and the weakening of body and mind; such as, the use of alcoholic liquors and tobacco, card-playing, dancing, attendance of theaters . . . and meetings of secret societies . . .* " In spite of these restrictions, MacRae presses on, growing closer not only to his young lady, but also toward an abiding faith. By the end of the book, he acquires both.

W. Wyeth Willard's *Fire on the Prairie* (1950) is the first full-length history of Wheaton College. Willard, a pastor and Navy chaplain, was a thrice-decorated veteran of World War II who also received the Legion of Honor Medal for outstanding heroism in the battle of Tarawa. In 1946, he was appointed assistant to the president of Wheaton College. His other books are *Steeple Jim* and *The Leathernecks Come Through*. (Courtesy of Wheaton College Archives and Special Collections.)

For 100 years, the literary society system provided Wheaton College students with an arena for oratory and parliamentary procedure. The Philomathean Society formed at the Illinois Institute in 1855, with mixed sexes. Concerned, Jonathan Blanchard remedied that in 1864, stating, "There must be a separation in this matter." And so the new rule: literary societies are either completely male or female. Pictured is the Aelioan Literary Society, 1897. (Courtesy of Wheaton College Archives and Special Collections.)

The Philalethean Literary Society, 1901–1902, are probably performing a skit. Most of these costumed ladies are unidentified; but one very identifiable face is that of Elsie Dow, seen on the top row, fifth from the left, dressed in cap and gown. Dow later assumed the chair of the English department, serving for decades. (Courtesy of Wheaton College Archives and Special Collections.)

The Philalethean Literary Society, in the early 1900s, delightedly swarms this little fellow, who looks like he would rather be elsewhere. The boy is the "groom," and the woman behind is the "bride," but nothing else is known. He is William Winer Cooke Griffin, who trained as a printer's apprentice for the college at age 7. He later published a golf magazine, *The Young American Golfer*. (Courtesy of Wheaton College Archives and Special Collections.)

The Excelsior Literary Society was founded in 1872, exclusively for men. Here they stand behind Blanchard Hall. Students who pursued professional positions often remarked that their public-speaking and leadership skills were sharply enhanced because of their society interaction. An ever-diversifying curriculum offered similar opportunities for extemporaneous speaking, pushing the literary societies into oblivion. (Courtesy of Wheaton College Archives and Special Collections.)

The Beltonian Literary Society poses with Charles Blanchard and William Shakespeare. Disbanding in the late 1950s, Wheaton's literary societies lasted longer than any other college in Illinois. Its prohibition against secret societies and fraternities allowed the literary society to fill the void, providing a wholesome, nurturing environment. The student union now presents an array of fun, challenging activities. (Courtesy of Wheaton College Archives and Special Collections.)

Wheaton Academy was a Christian high school managed by the college from 1914 to 1944. When the academy relocated to a rural campus west of Wheaton, the building was used as the graduate school. It is now called Schell Hall, named for Dr. E. R. Schell, the academy's dean. The brick structure attached to Schell Hall is the heating plant, called the Industrial Building. (Courtesy of Wheaton College Archives and Special Collections.)

Born in Sycamore, Illinois, Elsie Storrs Dow (1859–1944), poet and professor, taught English at Wheaton College, serving as head of the literature department for five decades. She published one small book of verse. Edward Coray (who served as a pallbearer at her funeral) recalls in *The Wheaton I Remember*: "Dr. Dow was a medium large woman with graying hair and eyes that could smile or flash with indignation as the occasion warranted. I had both experiences of being in and out of her good graces, so I experienced seeing those eyes in both moods." Another affectionate remembrance is found in Frank Herrick's "An Appeal to Dr. Elsie S. Dow," who rhapsodizes, "The golden sheaves / From the ripe fields / Of your rich years / Bring us to glean. / The Autumn of / The years of life / And sunset are / For men and trees/ And bending skies / The times of gold. / Pour out the wealth / Stored in your heart / In ceaseless floods / Of mighty song!" Dow was a first-rate teacher, constantly sharing her love of literature, and did much for establishing the college's reputation. (Courtesy of Wheaton College Archives and Special Collections.)

This monument marked the grave of James E. Burr, abolitionist. His efforts to assist escaped slaves to Illinois cost him five years in prison. Released, he simply renewed his involvement with the Underground Railroad. An admirer of Illinois Institute's unyielding antislavery stance, he requested that his body be buried on its campus. His grave lay a few yards from Williston Hall. (Courtesy of Wheaton College Archives and Special Collections.)

Until 1929, students decorated Burr's grave each spring. Nevertheless, it created an eerie sight for the girls residing in Williston Hall, a stone's throw away. Originally, the board of trustees authorized President Buswell to remove both the marker and the coffin to a local cemetery. Due to objections from older alumni, only the marker was taken. This less spooky tombstone marks the spot. A centennial memorial commemorating Burr's death was conducted in 1959.

CHRISTIAN CYNOSURE

JOHN ADAMS
Second President of the United States
Died July 4, 1826, on the Semi-Centennial of the Declaration of Independence, One Hundred and Fifty Years Ago.

John Adams never joined a secret society. His son, John Quincy, wrote, August 22, 1831, of him: "There was nothing in the Masonic institution worthy of his seeking to be associated with it. So said at that time the Grand Master of Masons, Jeremy Gridley, and such have I repeatedly heard my father say was the reason why he never joined the lodge."

VOL. LIX CHICAGO, JULY, 1926 No. 3
OFFICIAL ORGAN, NATIONAL CHRISTIAN ASSOCIATION
15 CENTS A COPY ESTABLISHED 1868 $1.50 A YEAR

After slavery, Jonathan Blanchard's most despised societal ill was Freemasonry, whose secretive, gut-wrenching oaths he felt threatened not only an open democracy, but also orthodox Christianity. In 1868, he and several others, including evangelist Charles G. Finney, established the National Christian Association (NCA), an organization dedicated to exposing secret societies. Its weekly newspaper, *The Christian Cynosure*, published lengthy articles and sermons written by Blanchard, pastors, and politicians, unabashedly detailing the intricacies of Freemasonry and its various associations. The NCA headquarters, a three-story graystone, stood at 850 West Madison Street in the Loop for over 100 years. The city of Chicago demolished it in 1982. Moving through various hands, the NCA and *The Cynosure* finally folded in the mid-1980s, due to low circulation and declining public interest in Masonic issues. The organization donated its books, pamphlets, and other paraphernalia to Wheaton College. Interestingly, fascination with Freemasonry and other secret societies has hotly resurged with the publication of Dan Brown's bestselling *The DaVinci Code*. Pictured is Pres. John Quincy Adams, avowed anti-Mason and author of *Letters on Freemasonry*. He wrote, "Masonry ought forever to be abolished. It is wrong – essentially wrong – a seed of evil, which can never produce any good."

51

The scholarly Dr. J. Oliver Buswell (1895–1977), Wheaton's third president, relaxes in his office. After Charles Blanchard's death in 1925, the administration commenced searching for a new president, eager to install a man who would faithfully execute the college's mission. As it happened, Buswell, a young pastor from Brooklyn, was conducting a week of evangelistic meetings at the college. So impressed were the students with Buswell that they requested him for consideration. After extensive discussion, the board of trustees unanimously agreed, hiring him in 1926. During his tenure, Buswell sought to strengthen the school academically and financially, enlarging library facilities and broadening faculty. However, in the years following, tensions mounted within the administration concerning Buswell's public disagreements with questionable decisions implemented by his denomination, the Presbyterian church. That, combined with personality conflicts, led to his firing in 1940. The students were assured that Buswell's release was not the result of broken integrity or faulty scholarship; rather, it was simply an impassable gridlock. Remaining friendly toward the college, he continued to visit until poor health slowed his travels in the early 1970s. (Courtesy of Wheaton College Archives and Special Collections.)

For decades, Westgate, situated on the edge of campus, served as the presidential manse. In 1936, it was presented to J. Oliver Buswell as a gift celebrating his 10th anniversary inauguration. The home was formerly owned by trustee John M. Oury. In the 1970s, the then-president moved to an off-campus property, allowing Westgate to be occupied by the alumni department. Here the Buswells wave, sometime in the late 1930s. (Courtesy of Wheaton College Archives and Special Collections.)

A UFO? No, but this otherworldly instrument is, in fact, dedicated to celestial exploration. Known as the Lemon, the wooden observatory, bought by Prof. Herman A. Fischer, stood from 1908 to 1972 on the front lawn of Blanchard Hall. It was replaced with a much more sophisticated telescope situated atop Armerding Science Hall. The Lemon was moved to the college's retreat, Honey Rock Camp, in Northern Wisconsin. (Courtesy of Wheaton College Archives and Special Collections.)

53

Dr. Harry A. Ironside (1876–1951) stands on the front lawn of Blanchard Hall in the 1930s. Born in Canada, but raised in California, Ironside heard evangelist D. L. Moody preach at a Los Angeles crusade in 1888, a pivotal moment determining the course of his own career. After joining the Salvation Army, Ironside eventually switched to worshipping with the Plymouth Brethren, ascertaining that they were more biblically accurate. Moving to Chicago, he served as pastor of Moody Memorial Church and sat on the boards of trustees of Wheaton College and Bob Jones University, both of whom presented him with honorary doctorates. A busy inner-city pastor, Ironside rented part-time rooms at the Plaza Hotel while his family lived in a house he had bought for them in Wheaton. Ironside's doctrinally rich sermons delivered from the Moody pulpit were transcribed into a series of squat, maroon-covered commentaries published by Loizeaux. This multi-volume set was for years a staple of pastors' libraries. Ironside, the so-called "Archbishop of Fundamentalism," was never formally ordained by a denomination or ruling body, hence the title of E. Shuyler English's biography: *H. A. Ironside: Ordained of the Lord*. (Courtesy of Wheaton College Archives and Special Collections.)

Seen here is a Wheaton College postcard from the late 1930s. "A School that is Different," states the card, citing its ranking as "fully accredited, class 'A' rating," with a "varied program of sports" and a "cosmopolitan student body of 700 from 37 states." At bottom center is Dr. Buswell in academic regalia, promoting the college as a center for serious theological study. (Courtesy of Wheaton College Archives and Special Collections.)

Harvard-educated Dr. Roger Voskuyl (1910–2005), professor of chemistry and dean of the faculty at Wheaton College (1983–1945), moved in 1950 to Westmont College, ably assuming its presidency. In 1942, Voskuyl secured a leave of absence from Wheaton College and participated in the Manhattan Project in New York, performing top-secret research in deuterium, or heavy hydrogen. Voskuyl's leadership skills were exceptional. (Courtesy of Wheaton College Archives and Special Collections.)

A late-1920s proposal for the student center was initially named in memory of Jonathan and Charles Blanchard. Due to the advent of World War II, plans were delayed for several years. A modified blueprint was completed in 1951 and dedicated as the Memorial Student Center by V. Raymond Edman "in memory of brave sons and daughters true who served God and Country in the Armed forces during W.W. II, especially those who gave to the last full measure of devotion."

This stolid building, proposed as the new gymnasium and auditorium, was presented in the late 1930s but never realized. The administration opted for a strict Colonial-style, reasonably affordable utilitarian design for future campus structures, steadfastly maintained to the present day. The new building eventually became the Edward A. Coray Gymnasium. (Courtesy of Wheaton College Archives and Special Collections.)

Aside from Billy Graham, Wheaton College has produced a significant number of world-class evangelists. Noteworthy is Torrey Johnson (1909–2002), founder of Chicagoland Youth for Christ. Raised in a Christian home but not yet a believer, he attended the college in the late 1920s, where he was befriended by fellow athlete Evan Welsh. During an evangelistic rally, Welsh approached Johnson, inquiring about his salvation. He gently pulled Johnson's arm, attempting to lead him to the altar. Welsh recalls, "It was the most unorthodox type of personal work – this tug of war act – but I think God was in it and I just kept pulling. . . . All of a sudden, without a word, he ceased struggling and, arm in arm, we went downstairs to the front of the church." Johnson later pastored Midwest Bible Church, located in a hostile neighborhood. But he relished challenges, and Northwest, once called "the fastest growing church in Chicago," flourished under his ministry. He then established Youth for Christ, dedicated to presenting the gospel through radio and itinerant evangelism. Billy Graham was its first field man. On Memorial Day 1945, Johnson preached to 65,000 at Soldier Field; in the autumn of that year, he conducted a successful week-long rally at Wheaton College.

The man in the bow tie, inspecting the chess game, is the brain-abundant Gordon H. Clark (1902–1984), associate professor of philosophy at Wheaton College in the late 1930s. The 1942 yearbook describes him thus: "Smugness in philosophy and appearance characterize Dr. Clark. Besides stumping his classes with syllogistic dilemmas, he delves into the depths of Aristotle and Plato. Before coming to Wheaton, Dr. Clark taught during 1924-36 at the University of Pennsylvania, where he also garnered a Ph.D." One of his students was Ruth Bell Graham (Billy's wife), who recollects his passion for "cold, hard facts." Impatient with sloppy thinking and a terror to inconsistent ideologies, he was actually a warm-hearted man capable of biting wit. In time, his unbending five-point Calvinism ran him afoul of the president, which eventuated his departure for Butler University, where he served as chairman of the Department of Philosophy for 28 years. His treatises and commentaries include *A Christian Philosophy of Education, Logic, The Atonement, The Trinity,* and *Thales to Dewey: A History of Philosophy*. Clark's long career as professor and author proves that orthodox, conservative Christianity can withstand challenging intellectual investigation. A publishing house called the Trinity Foundation exists to distribute his writings and taped lectures.

One of Wheaton College's finest athletes is featured in *Gil Dodds, The Flying Parson* (1948) by Mel Larson. A Boston native and champion indoor runner, Gil Dodds (1918–1977) sped the mile in 4:05.3 minutes at Chicago Stadium in 1948. Humble and hardworking, he frequently quoted Scripture during interviews. His sportsmanship was an inspiration to young athletes everywhere. Biographer Larson comments, "Where it may be, you'll find an unspoiled, unassuming and sincere man serving the God whose Son he knows personally and who is interested in spreading that Gospel to all corners of the earth." On that note, Edward Coray writes in *The Wheaton I Remember*, "When he was invited to speak anywhere he told them that he would talk about Jesus Christ. On that basis he would accept an invitation. . . . In some circles, the college was known as the place where Billy Graham was graduated and where Gil Dodds coached." Dodds invariably signed his autograph with a verse of scripture, usually Philippians 4:13 or Hebrews 12:1-2. One puzzled girl asked, "Is that your phone number?"

Preaching

and teaching God's Word, Billy Graham, pastor of the "Tab" and new Christian Council President, leads the members of his congregation in the way of the Lord. Stressing the winning of souls for the Kingdom of God, the "Tab" reaches a large part of the College family with this vital message.

West of Main on Wesley

UNITED GOSPEL TABERNACLE

A young, slender Billy Graham preaches at the United Gospel Tabernacle, nicknamed "the Tab." Graham attended Bob Jones University before transferring to Florida Bible Institute. From there he transferred to Wheaton College. After V. Raymond Edman assumed the presidency in 1940, leaving the pastorate of the Tab open, Graham filled it the following year. In his autobiography, *Just As I Am*, he writes, "I tackled my pastorate at the Tab with enthusiasm. I had to prepare and preach two sermons every week and lead a prayer meeting on Wednesday night. What I lacked in content I made up for in volume." In spite of his energy, Graham's schedule soon became problematic. He continues, "My responsibilities at the Tab did, however, turn out to be detrimental to my studies. To do more preaching, I had to do less studying, and the dilemma really developed there. I missed a great deal in the classroom." On his way home, Graham heard the news concerning Pearl Harbor, sharpening his awareness of life's brevity. At that moment, he recalls, "the pastoral ministry to members of the Tab's congregation deepened along with the preaching. Life and death were not abstractions to us anymore. . . " The Tab congregated at the Masonic lodge on Wesley Street. (Courtesy of Wheaton College Archives and Special Collections.)

Dr. Carl F. H. Henry (1913–2003) enrolled at Wheaton College in 1935 after hearing a talk by Dr. Buswell. He later taught journalism at the college and then instructed at Northern Baptist Theological Seminary while pursuing a second doctorate at Boston University. Henry's seminal work is the magisterial *God, Revelation and Authority*. He was the first editor of *Christianity Today*, accepting Billy Graham's invitation to fill the office. (Courtesy of Wheaton College Archives and Special Collections.)

Another outstanding alumnus is Percy Crawford (1902–1960), who attended the college between 1927 and 1929. He was the first president of the King's College, an institution modeled on Wheaton College. Beginning his career in radio, he holds the distinction of being the first television evangelist, broadcasting *Youth on the March* in 1949 from Philadelphia. After his death, Crawford's family continued his various ministries. (Courtesy of Wheaton College Archives and Special Collections.)

College Church of Christ, built in 1925 and situated on a sodden terrace, was dedicated by W. B. Riley. The church's pastor was Dr. J. W. Welsh, who served as interim college president between Charles Blanchard and Buswell. The congregation outgrew the church in 1936, handing it over to the college, which had outgrown its chapel in Blanchard Hall. The church was rechristened as the Orinda Childs Pierce Memorial Chapel. (Courtesy of Wheaton College Archives and Special Collections.)

The interior of Pierce Chapel, seen here in the 1940s, was used for weekly chapels, music, prayer meetings, evangelistic rallies, and other campus events. Funds raised to purchase it were presented to Buswell as a surprise gift on his 10th anniversary as president. Today the student body convenes in Edman Chapel for larger services, with Pierce used for more intimate worship services and other functions. (Courtesy of Wheaton College Archives and Special Collections.)

Wheaton College has experienced moments of particular spiritual refreshment. In 1943, President Edman ordered the suspension of classes, requesting that all students and faculty spend time in prayer, resulting in a revival. Over 30 percent of the class of 1943 surrendered to full-time Christian service, either at home or overseas. The most recent visitation occurred in 1995, related in *Accounts of a Campus Revival*. (Courtesy of Wheaton College Archives and Special Collections.)

Roty J. Snell wrote over 76 mysteries for boys and girls. A graduate of Wheaton Academy and College, he served as a missionary in Alaska before acquiring a master's degree from the University of Chicago in 1916. From there he journeyed to France with the YMCA before permanently settling in Wheaton, submitting his first novel to Christian publisher David C. Cook. Snell could compose an astounding 1,800 words in 20 minutes.

WETN, the Wheaton College radio station, began in 1947, steadily adding new personnel, programs, and equipment. Still operating, the station broadcasts chapel messages, contemporary Christian music, and play-by-play coverage of home games. Beginning the first day of December, WETN traditionally plays 24 hours of Christmas music until New Year's Day. The station is located in the lower level of the Billy Graham Center. (Courtesy of Wheaton College Archives and Special Collections.)

The guy scoring with the pigskin is expressing either agony or bliss, or both. Football players practice in the mid-1940s. On the horizon is the Lemon (left) and Williston Hall, the women's dormitory (right). In 2000, the college changed the name of its athletic teams from the Crusaders to the Thunder, to avoid potential conflicts for Wheaton College graduates in Islamic countries. (Courtesy of Wheaton College Archives and Special Collections.)

On the same day as Buswell's dismissal, the administration approached V. Raymond Edman (1900–1967), chairman of the department of history and social sciences, to serve as acting president. In the years ensuing, Edman proved to be a particularly apt choice, skillfully guiding the college through the events of World War II and the Korean War, both claiming the lives of Wheaton graduates, and up to the turbulent 1960s. Through aggressive fundraising, Edman spearheaded much-needed campus expansion. In addition to his administrative activity, he wrote popular devotionals, including *Disciplines of Life* and the autobiographical *Not Somehow – But Triumphantly!* Following his retirement in 1965, Edman accepted the position of chancellor, serving on the boards of multiple Christian organizations. On September 22, 1967, he was asked to preach in Edman Chapel, a routine responsibility for faculty. In his message, entitled "In the Presence of the King," he explained the necessity for preparing one's heart before standing in the presence of royalty, drawing parallels to the life of prayer. Ten minutes into his sermon, he suffered a fatal heart attack while standing at the podium, collapsing before the entire assembly. Edman's life—and spectacularly appropriate demise—marked generations of students. (Courtesy of Wheaton College Archives and Special Collections.)

In 1956, five courageous missionaries—Jim Elliott, Nate Saint, Roger Youderian, Pete Fleming, and Ed McCully (three of whom were Wheaton College graduates)—were slaughtered in Ecuador by the notoriously deadly Waodani Indians while attempting to initiate a relationship with the tribe, an event which made the cover of *Time* magazine. Consequently, their deaths prompted countless others to answer the call to missions. In fact, Elizabeth Elliott, Jim's widow, and Rachel Saint, Nate's sister, returned to the tribe as replacement missionaries, learning the language and translating Scripture. Today the Waodani are a peaceful, hospitable people, meeting regularly for church services beneath the jungle canopies. In the photograph, Dr. V. Raymond Edman baptizes Dayuma (the first convert resulting from their efforts) at First Evangelical Free Church in Wheaton. Her tale is told in *The Dayuma Story*, by Ethel Emily Wallis. The inspiring story of the missionary martyrs is chronicled in Elizabeth Elliot's *Through Gates of Splendor, Shadow of the Almighty* and *The Savage My Kinsman*. After Rachel Saint's death in 1994, her son Steve moved to Ecuador to continue working with the Waodani. (Courtesy of Wheaton College Archives and Special Collections.)

Billy Graham, a student during the Edman era and later a close friend, delivers the eulogy on the same platform where the president collapsed. Graham remembers, "He loved this college until there came a time when the name Wheaton was almost synonymous with the name Edman. . . . I never made a major decision, including the choice of my wife, without consulting him." (Courtesy of Wheaton College Archives and Special Collections.)

An Honor Guard watches Edman's flag-draped casket in the foyer of Edman Chapel. (Courtesy of Wheaton College Archives and Special Collections.)

Holger Jensen, from the class of 1921, thumbs through photographs of Edman, choosing an assortment of angles and expressions from which to fashion a likeness. (Courtesy of Wheaton College Archives and Special Collections.)

Jensen and his wife, Helen, inspect their sculpture of V. Raymond Edman. The bust is displayed in the lobby of Edman Chapel. (Courtesy of Wheaton College Archives and Special Collections.)

As the student population expanded, so did its need for an all-encompassing assembly space. In 1959, ground was broken for the $1.5 million chapel-auditorium. Edman Chapel, named after V. Raymond Edman, seats 2,400 persons and contains classrooms, coatrooms, a kitchenette, a recording booth, and a pipe organ chamber. In addition to chapel services, it is used for glee clubs and the annual artist series, presenting musicians, actors, and orchestras from the world over. Several presidents and hopefuls have stumped here. A few years ago, Bono of U2 spoke here, directing attention to various health crises in Africa. (Courtesy of Wheaton College Archives and Special Collections.)

Wheaton College's fifth president, Hudson Armerding, smiles confidently amid a crowd of hipsters. A Wheaton College graduate, World War II veteran, pastor, and former dean of Gordon College, Armerding assumed the presidency in 1965. In *Tender Warrior* (1993), a key text of the Promise Keepers movement, Stu Weber, former U.S. Army Green Beret, now an Oregon pastor, recalls when, as a depressed, lonely freshman wandering the campus in the 1970s, he unexpectedly encountered the president on a winter night: "I looked up into the face of Dr. Hudson Armerding, the great-hearted president of Wheaton College. . . . I still don't know how he found me . . . He invited me to his home. . . . There in the warmth of his living room, with everyone else in the house long asleep, he fixed two cups of tea. We talked. And talked. He became my friend. He still is. One of a half-dozen men who have marked my life, Hudson Armerding will always be a consummate King-Warrior-Mentor-Friend to me." Armerding resolutely guided the college through years of national unrest, assuring its historical status as a conservative Christian institution. He retired from the office in 1982 and now resides in Pennsylvania. (Courtesy of Wheaton College Archives and Special Collections.)

Dr. Hudson Armerding chats with novelist Madeleine L'Engle, deliverer of the 1977 commencement address. The Newbery and Caldecott Award-winning author of A *Wrinkle in Time* and A *Ring of Endless Light* began speaking at Wheaton's Faith and Learning Conference in the early 1970s, developing a relationship that culminated in L'Engle donating her papers (manuscripts, correspondence, artwork) to the college. In *Walking on Water: Reflections on Faith and Art*, she writes, "The two colleges where I feel most at home . . . are Mundelein, in Chicago, which is Roman Catholic, and Wheaton, less than an hour away, which is Evangelical." She relates hearing news of Professor Kilby's death in her memoir *Sold Into Egypt*: "the person responsible for my own papers going to Wheaton . . . Clyde, gone from us. Another in a long line of griefs, though Clyde, like the patriarchs, died *full of years*." She has co-authored three books with poet and college alumna Luci Shaw. L'Engle has visited campus many times throughout the years. In her novel *Certain Women* (1992), she even names a character David Wheaton. (Courtesy of Wheaton College Archives and Special Collections.)

Charles W. Colson, author and speaker, signs books after lecturing at Wheaton College. Formerly special counsel to Richard Nixon, Colson acted as the president's "hatchet man," a perpetrator of abominable political tricks. In the tumultuous weeks following Watergate, a friend gave Colson a copy of C. S. Lewis's *Mere Christianity*, instrumental in his conversion to Christ. "Lewis's words seemed to pound straight at me," he recalls in *Born Again*, his bestselling memoir. Tried and convicted, he pled guilty to obstruction of justice in the Daniel Ellsburg case and served a seven-month sentence. In 1976, Colson founded Prison Fellowship Ministries. Collaborating with churches of various creeds and denominations, it has become the world's largest outreach to prisoners, victims, and their families. His frequent visits to prisons also prompted concerns about the efficacy of the American criminal justice system. As a result, he is one of the nation's most influential advocates for justice reform. In 1983, Colson established Justice Fellowship, the nation's largest faith-based criminal justice reform group. His papers are archived at Wheaton College, where the Colson Scholarship was established to assist ex-convicts with acquiring a Christian education. (Courtesy of Wheaton College Archives and Special Collections.)

Evan Welsh poses with his wife, Olena Mae, for a 1975 issue of *Alumni Magazine*. Among Wheaton's legendary personalities, Welsh was singularly adored. In spite of the fact that President Edman had been advised by a trustee that "a chaplain is a luxury we cannot afford," Welsh was hired in 1955, returning to his alma mater from a thriving work at Ward Memorial Presbyterian Church in Detroit. Previous to his Michigan pastorate, he had served for 13 years as pastor of College Church in Wheaton. Following his 1970 retirement, he was appointed to the chaplaincy of the Wheaton Alumni Association. A crew cut–headed, scratchy-voiced man, he was available at all hours to students, offering prayer and a listening ear. As chaplain, he frequently represented the college on the road, speaking at alumni dinners; but his passion was for one-on-one counseling, and he was often called upon to administer a wise word to a troubled soul. Evan and Olena Mae Welsh enjoyed hosting students in their home, conducting Bible studies and serving refreshments. One colleague remarks, "With certain people, you can see God walking alongside. Evan Welsh was one of those." Welsh died in 1981; Olena Mae died in 2005. (Courtesy of Wheaton College Archives and Special Collections.)

The cherubic Dr. Clyde S. Kilby (1902–1986) peruses a favorite text. Kilby acted as chairman of the English department from 1951 to 1966. Until the task of hospitality became too burdensome, students met regularly with him and his wife, Martha, enjoying cookies and conversation. His determination to vivify the slumping Christian imagination received encouragement from a close reading of C. S. Lewis, whose work he encountered in the 1940s. "When you read a book by C. S. Lewis," Kilby said, "you have the feeling that you've got hold of something bottomless." The scholars corresponded until Lewis's death in 1963. After Lewis, he actively pursued J. R. R. Tolkien, whom he met at Oxford in 1966. There Kilby assisted Tolkien with assembling the sprawling portions of *The Silmarillion*, which saw print in 1977, four years after Tolkien's death. Kilby relates his visit in *Tolkien and The Silmarillion*. In 1965, he established the Wade Center, using his correspondence with Lewis as its nucleus. From there he worked toward acquiring the manuscripts of G. K. Chesterton, George MacDonald, Owen Barfield, Charles Williams, and Dorothy L. Sayers. One faculty observes, "Even the undertaker was sad when Kilby died." (Courtesy of Wheaton College Archives and Special Collections.)

Kilby sits at C. S. Lewis's desk, with Lewis's wondrous wardrobe, an inspiration for the classic *The Lion, the Witch, and the Wardrobe*, standing behind. Actually, Lewis owned several wardrobes. This one, handcrafted by his grandfather Hamilton, was acquired in 1973 at a fiercely competitive auction. Lewis's desk was purchased during the same trip. Both are displayed at the Marion E. Wade Center. (Courtesy of Wheaton College Archives and Special Collections.)

Kilby opens a crate, presumably just arrived from England, and carefully removes precious manuscripts before a thrilled library staff. Kilby's acquisitions were first housed in Jonathan Blanchard's old office at Blanchard Hall. As the collection expanded, it relocated to this room in Buswell Library. It, too, soon overflowed. (Courtesy of Wheaton College Archives and Special Collections.)

Frederick Buechner, minister and novelist, signs books on C. S. Lewis's desk. In the late 1970s, the college initiated a relationship with Buechner that resulted in the acquisition of his papers in Special Collections. In *Telling Secrets*, he remembers, "In the fall of 1985 I moved west . . . the place I was heading for was Wheaton College. . . . They have a great collection there of the manuscripts and papers of people like C.S. Lewis . . . and because I could think of no more distinguished company than theirs among whom to have my own literary remains molder, a year earlier I had offered them everything I had stowed away. . . . " He continues, "I knew it was Billy Graham's alma mater. I knew it was evangelical without any clear idea as to what that meant. . . . If I had known that they had to pledge also not to dance, of all things, I think that I would probably have been horrified enough to turn down the invitation on principle. The irony is that if I had done so, my life would have been immeasurably impoverished." Buechner's books include *The Book of Bebb*, *Son of Laughter*, and *Godric*. He has been nominated for a National Book Award and a Pulitzer Prize. (Courtesy of Wheaton College Archives and Special Collections.)

The new Marion E. Wade Center, constructed in 2001, was designed to resemble stately architectural styles seen on the campus of Oxford University. Artifacts like Lewis's wardrobe and Tolkien's desk are publicly displayed, but primary manuscripts and other sensitive items are contained in a climate-controlled vault. Since the cinematic release of *The Lord of the Rings* and *The Lion, the Witch, and the Wardrobe*, foot traffic has tripled.

In addition to storing administrative documents, Archives and Special Collections, separate from the Wade, maintains material relating to alumni and friends of Wheaton College. For example, the archives possess the manuscripts of journalist and Catholic conservative Malcolm Muggeridge (1903–1991), author of *Something Beautiful for God*, a biography of Mother Teresa. Below Muggeridge's portrait are his typewriter and his masks of poet William Blake and Christian mathematician Blaise Pascal, favorite authors.

77

In 1963, Marshall Erb uncovered the bones of this mastodon while excavating a pond for Joseph Sam Perry, who lived on a floodplain on the DuPage River. After reconstruction, it was unveiled in 1975. Whereas it had been stuck in mud for centuries, it is now destined to rotate in the Edwin F. Deicke Exhibit Hall, as a pre-recorded voice cheerily narrates its mournful history. (Courtesy of Wheaton College Archives and Special Collections.)

Billy Graham poses with Harold Anderson, contractor, in front of the incomplete Billy Graham Center (BGC), the realization of a years-long dream for the college. Although some students and alumni feared that its construction meant that the venerable Wheaton College would become "Billy Graham University," this proved unfounded. The BGC is used for classrooms, offices, and a marvelous museum featuring the history of American evangelism. (Courtesy of Wheaton College Archives and Special Collections.)

STEPS TOWARD APOSTASY
AT WHEATON COLLEGE
BY WILHELM E. SCHMITT

Considering the length of the college's history and the sprawl of its influence, it is understandable that disagreement arose concerning its pedagogy and shifting moods. A rather strident critique is found in *Steps Toward Apostasy at Wheaton College* (1966) by 1954 alumnus Wilhelm E. Schmitt, who chronicles what he sees as Wheaton's descent into communism and liberalism in the late 1950s. He warns, "It is my contention that unless the trustees and alumni act immediately to identify and oust the small but vicious clique that persecutes patriots but coddles collectivists and welcomes socialists and subversives to the campus . . . Wheaton College will soon be lost to the Christian anti-Communist effort." Among other issues, he cites the presence of visiting speakers like historian Arnold Toynbee, journalist Harry Golden, and ecumenist Arthur Glasser as indicators of the school's moral slump. A popular lecturer and occasional columnist, Schmitt established one of the first bookstores in Northern California specializing in anti-Communist and anti-Collectivist literature.

Betty Smartt Carter's comedic mystery, *The Tower, the Mask and the Grave*, is set on a campus suspiciously resembling Wheaton College. The illustration on the cover is a ringer for Blanchard Hall. A Wheaton College graduate, she recently published *Home Is Always the Place You Just Left*, which *Books and Culture* editor John Wilson calls "ruthlessly honest and seriously funny," and "one of the finest contemporary spiritual autobiographies." She recalls her undergraduate years: "In the fall of 1983, I took my cynical self north to Wheaton College, the very flower of evangelical Christianity. The school had a fine academic reputation, but it was best known for turning out missionaries, evangelists, and martyrs, not to mention the odd Republican politician . . . My love for Wheaton is now so great that it's hard to remember why I disliked it when I first went. But I did." She further relates her spiritual pilgrimage, interacting with professors and students, moving closer to owning a solid faith. "There's only one way to enjoy a Christian college," she observes, "and that's actually to be a Christian." Smartt's narrative is often painful but ultimately triumphant. In addition to writing for Christian magazines, she wrote *I Read It in the Wordless Book*, a coming-of-age novel.

In *Let's Roll!* Lisa Beamer relates the tale of her husband, Todd Beamer (1968–2001), a passenger aboard Flight 93 over Pennsylvania when it was overtaken by hijackers on 9/11. As the terrorists positioned themselves, Todd quickly telephoned a GTE Airfone operator, alerting her about the attack. Signing off with his now-famous, "Let's roll!" he joined other defiant passengers who charged the undoubtedly surprised attackers, thwarting a plot to crash the plane into Washington, D.C. After reading the operator's summary of the call, Lisa writes, "The words 'Let's roll!' were especially significant to me . . . Just hearing that made me smile . . . because it showed he felt he could still do something positive in the midst of a crisis situation." Todd was raised in Wheaton and Glen Ellyn; he and Lisa met as students at the college. "From our first date," she recalls, "it was clear to me that Todd was a guy who had a clear focus on life . . . *Mmm*, I thought. *Motivated, intelligent, fun to be with, great sense of humor, quick to smile, and funny, too. This guy could be a keeper.*" This photograph is printed in the 1991 Wheaton College yearbook. (Courtesy of Wheaton College Archives and Special Collections.)

Here stands Blanchard Hall after a snowfall, a lovely sight. The mock-Norman profile of this grand edifice represents Wheaton College to many the world over. However, the college nearly lost all in the second decade of the 20th century. Its budget starved in the early 20th century; consequently, Charles Blanchard and the board of trustees attempted to sell the property. Theologian Lewis Sperry Chafer, looking for land on which to inaugurate a seminary, traveled from Chicago to Wheaton, meeting Blanchard at a downtown café. When Chafer asked how much the property cost, Blanchard, with considerable relief, responded that it was no longer for sale, as a benefactor had that very morning generously gifted the college with a hefty donation. His plans rejected, Chafer simply boarded the train and journeyed back to Chicago. After further searching, he discovered suitable land in Texas, which eventually became Dallas Theological Seminary. Judge Herrick, in one of many poems dedicated to the college, writes, "O College we delight to name; / Brave Titan from the giants sprung / At fifty years thou art but young / The Future is thy field of fame!" (Courtesy of Wheaton College Archives and Special Collections.)

Three
THE THEOSOPHICAL SOCIETY

From its national organization in Cincinnati in 1886, the Theosophical Society's administrative offices were located wherever the American president happened to reside. A section was opened in Hollywood, California; but as the society's membership mushroomed, it was decided that a permanent Midwestern base be established. Searching for adequate land, the society purchased 10 undeveloped acres in Wheaton, "nearly perfect," as Pres. L. W. Rogers comments in his proposal, and "practically meets every requirement." The asking price was $14,725, but negotiations brought it down to $11,280. The land was chosen for its centrality, convenient for the Chicago and Northwestern railroad, and close to Roosevelt Road, connecting the society to the western states. The main structure of the national headquarters was designed by architects Irving and Allen Pond of Chicago. During its early decades, the society functioned as a self-sustaining commune, growing its own fruit and vegetables and drawing its own well water. An interesting feature of the main building is its unisex restroom. When the author inquired why this was so, a receptionist reasonably responded, "Why not?" The address is 1926 North Main Street, reflecting the year of its construction. The property is now a 42-acre campus called Olcott. (Courtesy of the Theosophical Society.)

Something of the peculiar magnetism of Helen Petrovna Blavatsky (1831–1891), known as "HPB," is glimpsed in the famous 1889 "Sphinx" photograph. Born of Russian nobility, HPB studied metaphysical lore from her girlhood. After adventuring in Europe, she journeyed deep into Tibet where she established contact with Koot Hoomi and Morya, Tibetan adepts. Enlightened with their arcane messages, she moved to the United States and met Henry Steel Olcott; together they founded the Theosophical Society in New York City in 1875. Three years later, she and Olcott moved to Chennai (Madras), India, establishing Adyar, the international headquarters. In 1885, the exotic HPB settled in London to write *The Secret Doctrine* (1888), a basic text of Theosophy which purposes to explain the origins of the universe and humanity, offering bits from legends, myths, and scriptures. The text, often dense and cryptic, requires lengthy commentary from Theosophical scholars. One lesser-known admirer of HPB is Elvis Presley, who in his later career read portions of her writings to his audiences. The anniversary of her death is commemorated on May 8th, called White Lotus Day. (Courtesy of the Theosophical Society.)

HPB's friend and partner, Colonel Henry Steel Olcott (1832–1907) was co-founder and first international president of the Theosophical Society. An accomplished agriculturalist, lawyer, and Civil War veteran, Olcott developed an abiding fascination with paranormal activity, visiting sites related to supernatural phenomena. In the course of his excursions, he met HPB, sharing interests that led to the creation of the Theosophical Society. Moving to India with HPB, he there initiated a revival of interest in Buddhist culture. In fact, he was one of the first westerners to convert to Buddhism; and today Sri Lanka honors his contributions to Buddhist culture by celebrating Olcott Day on February 17th. His death left Annie Besant as the head of the international Theosophical Society. (Courtesy of the Theosophical Society.)

William Quan Judge (1851–1896), third of the society's cofounders, supervised American operations while his colleagues, HPB and Henry Steel Olcott, labored in India. During the volatile early years of splintering and controversy, HPB held Judge in the highest esteem, calling him the "heart and soul" of the Theosophical Society in America. After her death, he broke with the parent society and founded an independent section of the Theosophical Society. Irish by birth and a lawyer by trade, Judge first met HPB in New York and consequently converted to Theosophy, studying directly from her, even claiming to receive communiqués from the Great White Brotherhood. George Russell ("A. E."), mystic and poet, describes Judge in the magazine *Echoes of the Orient* as the "hero of the Iron Age," recognizing his contributions to Western occultism, a missioner for enlightening dim minds in a materialistic era. Judge lectured on Theosophy at the 1893 World Parliament of Religions in Chicago. He wrote two books, *Letters That Have Helped Me* and *The Ocean of Theosophy*. He died as the result of overwork and the effects of a lingering fever. Sitting upright on a sofa, his final words were, "There should be calmness. Hold fast. Go slow." (Courtesy of the Theosophical Society.)

One of the most intriguing Theosophical personalities is Dr. Annie Besant (1847–1933), second international president. Born Annie Wood in London, she entered a short-lived marriage with Frank Besant, a Church of England clergyman. As a girl she was a devout Anglican, but eventually embraced atheism, assuming leadership in the National Secular Society, where she met Charles Bradlaugh. Together they published Frank Knowlton's *The Fruits of Philosophy*—a treatise advocating birth control—and were unsuccessfully prosecuted. After the trial, Besant championed feminist causes, leading the London match girls' strike of 1888, and attained membership on the executive committee of the socialist Fabian Society. After reading HPB's *The Secret Doctrine*, she abandoned atheism and joined the Theosophical Society. In addition to her esoteric interests, Besant wholeheartedly involved herself with encouraging Indian Home Rule. Her numerous books include *Esoteric Christianity*, *In the Outer Court*, *Three Paths of the Dharma*, and *The Wisdom of the Upanishads*. She died in Adyar, India, where her body was burned on a funeral pyre. Note the sash, indicating her rank as a 33rd Degree Co-Mason, an offshoot Masonic order that admits both men and women. (Courtesy of the Theosophical Society.)

This 1907 pamphlet advertises a visit by Annie Besant, "renowned student of occultism," as the header states, speaking at Kimball Hall (243 Wabash) in Chicago. She delivered four public lectures: "Psychism and Spirituality," "The Place of Masters in Religions," "The Value of Theosophy in the World of Thought," and "Theosophical Work in India." (Courtesy of Wheaton College Archives and Special Collections.)

The back of the pamphlet shows the library at Adyar, international headquarters for the society, where it remains under Rhada Burier, national president. Before moving its national operations to Wheaton in 1926, the society maintained a book room in Room 426, at 26 Van Buren Avenue in Chicago, which provided a full catalogue of Theosophical titles. (Courtesy of Wheaton College Archives and Special Collections.)

88

In this 1920s photograph are Annie Besant, C. Jinarajadasa, and the bearded C. W. Leadbeater (CWL). An Anglican priest when he joined the society, Leadbeater met HPB shortly thereafter, establishing himself as a clairvoyant who, like Blavatsky, psychically connected with the Tibetan adepts, or "Mahatmas." Living in India in 1909, CWL spotted an unusually radiant magnetic aura surrounding Jiddu Krishnamurti, a youth bathing on the beach in Adyar. Perceiving Krishnamurti to be the "World Teacher"—similar to Moses, Buddha, or Zoroaster—CWL recruited him for the momentous mission, training the boy for the next few years until the boy commenced traveling with Besant as his mentor. Leadbeater later moved to Australia, joining the Liberal Catholic Church, which maintains strong connections with the Theosophical Society. CWL hosted national president L. W. Rogers at his home when the American toured Down Under. Leadbeater's books include *Chakras*, *The Inner Life*, *The Hidden Life of Freemasonry*, and *The Science of the Sacraments*. He died in 1934. (Courtesy of the Theosophical Society.)

C. Jinarajadasa (1875–1953), or "Brother Raja," served as the fourth international president of the society, beginning in 1945. According to a friend, he could be either "endearingly" or "exasperatingly" eccentric. As a young man in the 1890s, Jinarajadasa assisted C. W. Leadbeater as secretary, tidying manuscripts for publication. A graduate of St. John's College in Cambridge, he addressed audiences in Spanish, French, Italian, English, and Portuguese. In his office was a placard stating, "I am that Work. That Work am I," reflecting his utter absorption in Theosophy. A man of learning and culture, he strongly encouraged involvement in the arts, stating, "character building can be hastened through the mind and emotions being made more and more acquainted with art. . . . You so link men to you through art that their suffering teaches you lessons, and their joys give you enthusiasm and strength." Weakened with illnesses, he retired from office in 1953, embarking on a worldwide tour. When he reached the United States, he realized that he would not live to see the completion of his circuit and journeyed to the Wheaton campus where he died in room number four on the first floor of the main building. The Brother Raja Memorial Grove at Olcott is named in his honor. (Courtesy of the Theosophical Society.)

Jiddu Krishnamurti (1895–1986) sits for a portrait during the height of his fame. After C. W. Leadbeater convinced him of his unique destiny, the Order of the Star in the East (OSE) was duly founded to advance Krishnamurti's worldwide ministry. For the next several years, he traveled extensively with his friend and protector, Annie Besant, speaking at various Theosophical events, readying humankind for his unveiling. Disillusioned with his mission and inconsolably pained by the premature death of his brother, Nitya, he dissolved the OSE in 1929, renouncing his messianic destiny in a radio broadcast. Krishnamurti then parted with the society before charting his own course as a spiritual teacher, declaring that truth is a pathless land and that his sole interest was to set people free without condition. George Bernard Shaw regarded him as "a religious teacher of the greatest distinction who is listened to with profit and assent by members of all churches and sects." In 1985, Krishnamurti addressed the United Nations, who honored him with a Peace Medal. The Krishnamurti Foundation is maintained at his home in Ojai, California, to propagate his teachings. Most of his numerous books are transcriptions of interviews and lectures. (Courtesy of the Theosophical Society.)

Annie Besant presides over the Laying of the Cornerstone in Wheaton, 1926. Inside the copper box are the following texts: *The Secret Doctrine; Old Diary Leaves; The Ancient Wisdom; Man, Whence, How and Whither; At the Feet of the Master; The Golden Book of the Theosophical Society;* and *The Parchment.* Besant spoke again in 1929, accompanied by Krishnamurti. A plaque quotes her words: "Be strong; be brave; be true." (Courtesy of the Theosophical Society.)

The national headquarters in Wheaton is almost completed in this 1926 photograph. The society, non-sectarian, undogmatic, and nonpolitical, rests upon three declared objects: to form a nucleus of the universal brotherhood of humanity, without distinction of race, creed, sex, caste or color; to encourage the comparative study of religion, philosophy, and science; and to investigate unexplained laws of nature and the powers latent in humanity. (Courtesy of the Theosophical Society.)

Krishnamurti and Annie Besant attend a 1929 summer school at the Wheaton campus, guided by their host, L. W. Rogers, national president. Rogers, activist, lecturer, and writer, joined the society in 1903. His organizational skills and constant enthusiastic speaking on behalf of the Theosophical Society were essential to its establishment in the United States. The main structure is called the "L. W. Rogers Building" in his honor. (Courtesy of the Theosophical Society.)

Attendees gather on the front lawn of the Theosophical Society during the 1936 summer school. Notable adherents to Theosophy include W. B. Yeats, Mahatma Ghandi, Christopher Isherwood, Thomas Edison, Aldous Huxley, Gen. Abner Doubleday (inventor of baseball), and L. Frank Baum who, according to scholars, composed *The Wizard of Oz* as an esoteric *Pilgrim's Progress*, displaying key Theosophical concepts. (Courtesy of the Theosophical Society.)

Theosophists proceed down the front driveway for the dedication of the archway on July 22nd, 1940. Designed by Claude Bragdon (1866–1946), writer, architect, and painter, the arch displays the society's stylized emblem and motto, "There is no religion higher than truth." The pillars are topped by two of the five Platonic solids (described in Plato's Timaeus), the cosmic material with which the universe is composed. Behind the L. W. Rogers Building is the Olcott Labyrinth, patterned after an ancient Cretan design; the labyrinth presents a journey metaphor, intended to assist the pilgrim with relaxation, mediation, and inner healing. The society is also concerned with social aid. In 1908, Annie Besant founded the Theosophical Order of Service, dedicated to educating the underprivileged, providing disaster relief, advancing free medical care, and encouraging animal welfare. Its motto is "A union of those who love in the service of all who suffer." Another agency based on theosophical principles is the Humanitarian Service Project, founded by Floyd and Karole Kettering in 1979. The project generously serves senior citizens with monthly grocery delivery and provides needy children and families with gifts during Christmas and birthdays. (Courtesy of the Theosophical Society.)

The Henry S. Olcott Memorial Library at the Theosophical Society contains more than 18,000 volumes, including audio and visual, relating to esoteric Christianity, Theosophy, philosophy, psychology, parapsychology, mythology, and mysticism. Also displayed are items belonging to chief theosophists, such as Madame Blavatsky's tiara. Materials are available to registered patrons living within the United States. The library, organized on split levels, is open to the public. This photograph is from the late 1960s.

The luxurious lobby of the Theosophical Society functioned as a parlor until several chairs and a dividing drapery were removed. The receptionist sits here, receiving guests, mail, and packages. A handicapped-accessible elevator was recently installed, blending perfectly with the decor. Also displayed in the lobby are sculptures, paintings, portraits, and an illustrative wall mural. (Photograph by Scott Albert; used by permission of the Theosophical Society.)

Surrounding the walls of the reception area in the L. W. Rogers Building is a pastel-colored mural depicting cosmogenesis, the theosophical sequence narrating the unity of life throughout the ages and the evolution of consciousness of forms. World religions and philosophies are suggested by ancient symbols and figures such as the Buddha, representing tranquility, and Roman Catholic and Greek Orthodox bishops, ecclesiastical figures representing the embodiment of spiritual power in evolved humankind, both standing by the River of Life. World motherhood is portrayed by a mother holding her baby who clasps a lotus flower, a symbol of perfected creation. The west wall begins with a prismatic sun, its rays nourishing primitive forms leading up to vertebrates, moving toward humanity. The sun is also emblematic of the destroyer of fragile life, later to be reincarnated; it is also the bringer of life, carrying its eternal fire to humankind. The artist, Richard B. Farley, comments "Life is all one plan, one balance, with many manifestations, many things in their place." (Mural photographs by Scott Albert; used by permission of the Theosophical Society.)

Radha Burnier, international president, chats with the Dalai Llama, who visited Wheaton in 1980. When an assistant asked what he desired for breakfast, the exiled Tibetan replied that he wanted bacon, eggs, and cereal. However, the society is vegetarian and was unable to comply with the bacon. The other foods were acquired at the Jewel across the street. His stay was accompanied by a full-time police guard. (Courtesy of the Theosophical Society.)

Llama Anagarika Govinda (1898–1985), born Ernst Lothar Hoffman, and his wife, Li Gotami, lecture in the Olcott Library. He is the author of the spiritual memoir *The Way of the White Clouds*, chronicling his observations and adventures in Tibet. In 1933, Govinda founded the Order of the Arya Maitreya Mandala, dedicated to propagating the Tibetan religious heritage. His final years were lived near San Francisco. (Courtesy of the Theosophical Society.)

Meet the lovely Betty Bland, president of the Theosophical Society in America. Presidents are limited to an elected three-year term, capping at three terms. Bland's husband, Dr. David H. Bland, is the business manager of the Theosophical Publishing House, located in the Joy Mills Building at Olcott. The Blands are hospitable, gracious Southerners, and the author is exceedingly grateful for their friendship and participation in this project. (Courtesy of the Theosophical Society.)

Four

Saints' Rest

The presence of Wheaton College has for years invited a host of associate interests, earning the city its nicknames, "Saints' Rest" and the "Protestant Vatican," although not all parties are Protestant. Headquartered here, either formerly or currently, are such organizations as The Evangelical Alliance Mission (TEAM); Peter Deyneka Russian Ministries; *His* magazine; Harold Shaw Publishers; Tyndale House (publishers of the *Left Behind* series); Marianjoy Rehabilitation Clinic; Conservative Baptist International; *Christianity Today*; Van Kampen Press; Scripture Press; Creation House; Chapel of the Air; Hope Publishing (hymnals); Good News Publishers/Crossway Books; National Association of Evangelicals; Hitchcock Publishing (business magazines); Pioneer Clubs; Christian Working Woman; World Relief; Sword of the Lord; and the Evangelical Child and Family Agency. Of course, accompanying the faithful are their places of worship: St. Michael's Catholic; First Baptist Church; College Church; Wheaton Bible; Trinity Episcopal; First Presbyterian; Praise Fellowship; Bethany Chapel; Wheaton Christian Center; Second Baptist; St. Paul's Evangelical Lutheran; and many more (over 50). As missionaries retired from the field, they too settled in Wheaton's docile neighborhoods. These days, however, as property and utility taxes increase and electronic media renders geographical proximity to the college less necessary, the city sees fewer non-student saints resting within its borders.

The first Methodist class formed in 1853, meeting in the depot, then above a store. After a few more moves, the church settled in a permanent building on Main Street, used between 1860 and 1901, when Judge E. H. Gary donated $83,386 for this magnificent Romanesque structure. It was the largest assembly space in DuPage County, used for weddings, graduations, and political events. (Courtesy of Gary United Memorial Methodist Church.)

On Monday, January 7th, 1929, two Wheaton College students returning on a late train from Chicago saw fire blazing from the windows of Gary Methodist, probably resulting from an overheated furnace. They awakened the pastor, who called the fire department; however, by 1:30 a.m., the once glorious building lay in ruins. The board of trustees met the next day and passed a resolution to immediately rebuild. Pictured is the prefire sanctuary. (Courtesy of Wheaton College Archives and Special Collections.)

The cornerstone for the new Gary Methodist was laid on March 2, 1930, and by the end of the year, this structure, perpendicular neo-Gothic rather than Romanesque, stood tall, solid, and ready for occupation. Officials from the 1934 World's Fair proclaimed it as the most "beautifully designed church" of its period. (Courtesy of Gary Memorial United Methodist Church.)

Like everybody else, the grand old edifice has aged, requiring renovation to meet changing congregational needs. This architect's sketch depicts Gary United Methodist Church after all phases of construction are completed. The refurbishment will provide additional classroom and assembly space in addition to modern plumbing, heating, and lighting. (Courtesy of Gary Memorial United Methodist Church.)

St. Michael's eighth-grade graduating class of 1932 gather with Father Epstein and Father Lavery. The first St. Michael's burned in 1892. The structure was demolished in 1983. The church complex occupies the entire block bordered by West, Willow, and Illinois Streets. (Courtesy of the Wheaton Historic Preservation Council.)

Franciscan Sisters School stands six stories high, with a church and chapel on the grounds. The Franciscans are a community of vowed women, religious and covenant (associate) women, and men whose mission is to live the Gospel following the spirit of Francis and Clare of Assisi and foundress M. Clara Pfaender. (Courtesy of the Wheaton Historic Preservation Council.)

Worshippers pour out of Wheaton Bible Church after a service. The congregation assembled at Wheaton College until buying this property on the corner of Union Avenue and Cross Street. This structure was demolished to allow for a bigger, more modern facility. After impressive growth, they plan for yet another move, this time to property west of Wheaton on Highway 64.

Here is a wider c. 1950 photograph of the old Wheaton Bible Church. The congregation has enjoyed a history of faithful, gifted pastors, including J. C. McCauley, Malcolm Cronk, and Richard H. Seume, a powerful influence on Dr. Charles Swindoll, former president of Dallas Theological Seminary. The current pastor is Rob Bugh, who emphasizes fresh perspectives on the church's mission, vision, and values. (Courtesy of the Wheaton Historic Preservation Council.)

Here stands the First Baptist Church of Wheaton, before relocating to its new premises on Main Street. This structure, sadly, is gone, demolished in 1960. First Baptist is now located in a modern building a few blocks north, where the parishioners conduct Vacation Bible School and minister to the immigrant population living in the apartments immediately south. (Courtesy of Wheaton College Archives and Special Collections.)

Trinity Episcopal Church was established in 1875, but did not receive its current building until 1881, on the southwest corner of Wesley and West Streets. Trinity has been remodeled several times throughout the years; but the original church is still used for small weddings and services. The photograph shows the chapel in the late 1950s. (Courtesy of Wheaton College Archives and Special Collections.)

Isobel Kuhn (1901–1957), missionary and author, courageously journeyed with her husband, John, to southwest China to labor among the Lisu tribe. This photograph accompanied her application to China Inland Mission. Kuhn's books include *In the Arena*, *By Searching*, and *Ascent to the Tribes*. Stricken with cancer, she spent her final days in Wheaton, dying at 123 Scott Street. (Courtesy of the Archives of the Billy Graham Center, Wheaton, Illinois.)

Shortly after World War II, Bill and Mary McCartney of the Plymouth Brethren established a worshipping assembly in Wheaton, meeting at Bethany House (above). In the early-1950s, the assembly sold this grand manse to a developer who demolished it to make way for an apartment complex. The new (1955) church, Bethany Chapel, is located at 404 North President Street, immediately south of where Bethany House stood. (Courtesy of Gerald and Jane Hawthorne.)

John R. Rice (1895–1980), pastor, revivalist, and industrious author, resided in Wheaton from 1940 to 1963. As with many ministries, Rice chose the area for its centrality, establishing offices for his publishing house and newspaper, both called the *Sword of the Lord*. Rice and his wife, Lloys, raised six daughters, all of whom attended the college. Without compromising his own convictions, he managed in his long career the extraordinarily difficult accomplishment of gaining the respect of diverse Christian voices. Dr. Jimmy Swaggart, a representative charismatic, modeled his early preaching on Rice's sermons. Dr. Dallas Willard, a representative Evangelical, dedicates a book to Rice, calling him a "giant." Dr. Jack Hyles, late pastor of First Baptist Church in Hammond, Indiana, a representative Fundamentalist from the 1950s to the 1970s, describes Rice as "the greatest Christian I ever knew." Rice wrote over 200 books and pamphlets, many still in print. In 1963, he moved operations from Wheaton to Murfreesboro, Tennessee, where it remains under the leadership of Dr. Shelton Smith. Rice's life is chronicled by his personal secretary of 46 years, Dr. Viola Walden, in *John R. Rice: The Captain of Our Team*. (Courtesy of Sword of the Lord.)

Dr. Bill Rice (1912–1978), John's half brother, also lived in Wheaton. Originally from Texas, Rice moved north to enroll at Moody Bible Institute in Chicago. Soon he gained a national reputation as revivalist, conducting evangelistic campaigns from coast to coast. In 1949, Rice accepted an invitation to lead a meeting in Africa. To raise funds, he and his wife decided to sell their home. He writes in *Cowboy Boots in Darkest Africa*, "Sell our home in Wheaton! The house we had lived in for eight years! . . . The house with the great big living room where I practiced calf roping on Super, our Great Dane dog!" When their daughter, Betty Ann, was diagnosed with meningitis, resulting in deafness, the Bill Rice family moved to Murfreesboro to establish the Bill Rice Ranch, a missionary endeavor dedicated to evangelizing deaf children. After Bill's death, the 1,300-acre ranch operated under the leadership of his son, Dr. Bill Rice III, who was born in Wheaton. A few years ago, Bill III returned to the city to show his wife, Mary, the old homestead on Naperville Road, only to discover that it had been demolished, replaced by a multi-storied office. (Courtesy of Bill Rice III.)

In his essay collection, *Which Way is Up?*, Bill Rice III writes briefly of happy childhood Christmases in Wheaton. An excellent Biblical expositor, Rice travels widely with his wife, speaking at churches and conferences. In 1989, the West Branch facility of the Bill Rice Ranch opened in Flagstaff, Arizona. Here he is pictured just entering the evangelism ministry in 1966. (Courtesy of Bill Rice III.)

In 1946, John R. Rice purchased this warehouse at 214 West Wesley Street for $7,000, which served the *Sword of the Lord* until it moved in 1963. Viola Walden writes that this was "a place of business where dedicated hands and minds got out the Gospel . . . all came to feel very much at home in Wheaton, as, in reality, there were at home. . . . [It] holds blessed memories of our 17 years of occupancy." (Courtesy of Sword of the Lord.)

108

Located in Wheaton for decades, the National Association of Evangelicals (NAE) is now headquartered in Los Angeles. The NAE, begun in 1942, sought to unite Evangelicals of differing stripes, attempting "to organize an Association which shall give articulation and united voice to our faith and purpose in Christ Jesus." Vacillating between the movement's strengths and weaknesses, the NAE stands as a representative voice for Evangelicals.

BOOKS
by MEN of
WHEATON

Storms and Starlight

by V. Raymond Edman. His life had its storms and starlight—slander, sarcasm, selfishness on the part of His fellow Galileans, and pleasant things like solace for heartache, and supply for human need. How He met these varied circumstances and what He can teach us for the strengthening and sweetening of our lives we can trace in *Storms and Starlight*. Most of the incidents treated are from the Gospel of Mark and the life of Christ. 240 pages, cloth, $2.50.

Disciplines of Life

by V. Raymond Edman. Dr. Edman's heart-warming and deeply spiritual advice from the pulpit and platform is here carried over to the printed page, at the same time retaining all of its originality and spice. These pages contain thirty-one disciplines of life arranged alphabetically for the reader's convenience. 254 pages, cloth, $2.00.

Archaeology and Bible History

by Joseph P. Free. Confirming Biblical history through archaeological discoveries has been the thrilling occupation of the author for almost a decade and a half. Dr. Free, head of Wheaton's Department of Archaeology, has made numerous study-trips to Palestine, the near East, and Europe. This book is of inestimable value to ministers, teachers and laymen who are looking for illuminating facts in Bible history. 416 pages, cloth, $5.00.

Blazing the Missionary Trail

by Eugene Myers Harrison. Second book in this author's series on "Heroes of the Faith." Seven missionary biographies from as many parts of the world, with a challenge to every Christian, including: James Wilson, missionary sea captain; John Geddie, messenger in Eastern Melanesia; Alexander Mackay, Roadmaker for Christ in Uganda, and others. 144 pages, cloth, $1.75.

The Fight for Palestine, in the Days of Joshua

by Carl Armerding. Chapter by chapter, an expository and devotional commentary on the Book of Joshua by an outstanding Bible teacher. It is done in such simple form that even he who is not a student of the Word will revel in the truth presented. 152 pages, cloth, $1.75.

The Light in Dark Ages

by V. Raymond Edman. A history of missions from the giving of the Great Commission to the beginning of modern missions under William Carey. This volume traces the story of the Great Commission in its first eighteen centuries, portrays its rise and early conquests, its decline in ages that were dark with superstitions and ignorance, yet with little candle lights of gospel truth, and its rising anew with the Reformation and the Age of Exploration. With map and index. 452 pages, cloth in textbook size (5⅜ x 8½ inches), $4.00.

The Story of Wheaton College!

Fire on the Prairie

by W. Wyeth Willard. The facts behind Wheaton College: how it started, who was responsible, what has transpired in the nearly 100 years of its life. 20 pages of remarkable pictures. Alumni, present students, parents, friends, all should have this book. A brief biography of the Blanchards who directed Wheaton College for more than half a century. 228 pages, cloth bound, $2.50.

How To Win Souls

by Eugene Myers Harrison. Every true believer in the Lord Jesus Christ may know just how to point others to the Savior, regardless of their arguments, ignorance of truth, or religious background. "How to Win Souls" is a detailed guide for the personal worker, outlining how to deal effectively with each group. Cloth bond, $2.00.

At your local bookstore or

Van Kampen Press WHEATON, ILLINOIS

Van Kampen Press of Wheaton produced several interesting books for a few years before disappearing in the mid-1950s. This advertisement from the college yearbook displays titles written by alumni and faculty, including the massive *Light in the Dark Ages* by V. Raymond Edman, who took a year-long sabbatical to write it. Another Wheaton publisher still very much in business is Tyndale House, founded by Kenneth Taylor, paraphraser of *The Living Bible* and author of several books, notably an autobiography, *My Life: A Guided Tour*. Boasting an impressive backlist of novels, family-oriented videos, and non-fiction, Tyndale's most famous product is the bestselling *Left Behind* series, authored by Jerry Jenkins and Tim LaHaye.

Five

All-American, Cosmopolitan City

For long decades, Wheaton stood distinctly apart from surrounding communities. Between here and St. Charles, Naperville, and Glen Ellyn, there were cornfields, gravel roads, farms, horse ranches, orchards—a sense of calm and wide country sky. As urbanites fled Chicago and became suburbanites in the 1950s and 1960s, the open spaces comprising "the land beyond O'Hare," as crime novelist Sara Paretsky calls it, forever closed, devoured by parking lots, bland sub-divisions, and ugly strip malls. Nevertheless, Wheaton remains a safe, quiet place, not merely an extension of Chicago but a world-class community in its own right, however tightly it rubs shoulders with its neighbors. In 1967, *Look* magazine and the National Municipal League named Wheaton an "All America City," the only one of the year to garner the honor, a fact proudly touted by the chamber of commerce. As Wheaton's industrial base expanded, international corporations came and went. Missionary agencies housed refugees from all over the planet; and an increasing number of foreign students enrolled not only at Wheaton College but also at National-Louis, Illinois Institute of Technology, and the College of DuPage. It is still a peaceful suburb, but Wheaton is also a spicy pot of multi-ethnic flavors, and the juices simmer most delightfully.

"Hey, Culligan man!" The advertising copy from the 1955 *Wheaton College Tower* reads, "Wheaton's soft water needs are met by Culligan's Soft Water Service, 231 East Front Street. Phones Wheaton 8-4100 or Elmhurst 4199."

Located in many buildings, always within 50 to 300 feet of the railroad, the Wheaton Post Office finally settled in this compact structure in 1933, on the corner of Wheaton Avenue and Wesley Street. Its interior was refurbished in the late 1990s, removing all of its old-time art deco charm. It is now much more functional for daily operations. (Courtesy Wheaton College Archives and Special Collections.)

Wheaton Trust and Savings, located on Hale Street, is seen here in the mid-1940s. (Courtesy of Wheaton College Archives and Special Collections.)

The facade of Gary-Wheaton Bank is seen in the 1950s, organized in 1874 by Elbert Gary and Jesse Wheaton. (Courtesy of Wheaton College Archives and Special Collections.)

Richard Burghardt (foreground) pours cement for a sidewalk that will accommodate a parking lot for his greenhouse, Flowers by Richard, at 220 West Chase Street. Owned by various hands, it was called Peterson's, Raap Greenhouse, and Sylvia's. Richard and his wife, Char, owned the greenhouse from 1952 to 1958, selling it to Wheaton College, which eventually moved the building (used for horticulture classes) across the tracks to Crescent Street, allowing for the construction of the Billy Graham Center. (Courtesy of Richard and Char Burghardt.)

Gloria Vickers and Tommy Chapman salivate over a glistening 1955 Buick at Suburban Buick Company's new showroom. These days Wheaton's car dealerships display their wares on Roosevelt Road.

Prince Ice Cream Castle, "the little stone castle on the corner," was a popular suburban hamburger chain, popular with both students and townies. The Castle was famous for its "one-in-a-million" malted milk. This little unit, seen in the early 1950s, is gone, replaced by a multi-storied bank.

Wheaton Pharmacy, seen here in the early 1950s, was located on the corner of Liberty and Hale Streets until moving across the street; the drugstore was a city mainstay until 2005, when it went out of business. Unfortunately, this lovely terra cotta facing was removed or covered. The train depot is seen just beyond the picket fence. The corner spot is now occupied by Ron's TV Repair Shop. (Courtesy of Wheaton College Archives and Special Collections.)

Kampp and Sons Funeral Home, seen in this c. 1955 photograph, occupied this building from 1935 to 1969. "Beauty and Dignity need not be expensive. . . " reassures the sign affixed next to the door. Over the years this space has served not only as a respected mortuary, but also as Doenges Office Products and One 20 Ocean Place, a gourmet restaurant. It is located directly across the street from the Wheaton Theater. The clock and marquee ("air conditioned for your comfort") are gone, but the parlor's stained-glass windows are yet visible on the western wall, a constant reminder to passersby not only of the building's storied history, but also of mortality. Kampp Williams Funeral Home is now located at 430 East Roosevelt Road.

Plumb Studio, owned by Wheaton College and used for student housing, was demolished in 1975 to make room for Buswell Memorial Library. First located at the corner of Franklin and Irving Streets, it was moved a few hundred feet north to allow for Nicholas Library. The house was initially owned by Dr. William Evans, respected theology professor at Moody Bible Institute and author of the much-used textbook *Great Doctrines of the Bible*. (Courtesy of Wheaton College Archives and Special Collections.)

The monument called "Wheaton's Road of Remembrance," commemorating area veterans, stood at the corner of Roosevelt and Naperville Roads. This beautiful open field long ago surrendered to the developers' bullying bulldozers. An occasional barn standing anomalously beside a row of tract housing is the only reminder of Wheaton's agricultural past. (Courtesy of the Wheaton Historic Preservation Council.)

Walter and Esther (Toofer) Kinnaman, long-time Wheaton residents and the author's beloved landlords, are seen here. For 40 years, the kindly Esther served as supervisor of the dining room at the Glen Oak Country Club, retiring with an honorary lifetime membership. Walter built houses, sailed boats, and told salty stories, often unprintable. Perhaps he acquired the golden gift of blarney from his father, Dr. John Ora Kinnaman, a reputable Egyptologist and editor of the *American Antiquarian and Oriental Journal*. Kinnaman, one of the first to enter King Tut's tomb, also claims to have discovered (with Sir W. Flinders Petrie) a chamber beneath the Great Pyramid containing scrolls that reveal the secrets of anti-gravity, squirreled away centuries ago by the Atlanteans. Perceiving that mankind is not ready for such knowledge, he disclosed its location to no one, dying in 1961 at age 84. Shortly before his passing, he established the Kinnaman Foundation to promote "Archaeology, Alternative Energy, Organic Farming Techniques and Alternative Health Modalities." Though Dr. Kinnaman was guardian of the treasures of Egypt, it was his son, in allowing the author to board in the Crow's Nest, who uncovered to him an equally priceless, treasure: Wheaton, Illinois. (Courtesy of Esther Kinnaman.)

Snow piles high on Seminary Avenue, immediately west of College Church, in the late 1950s. The white house on the left was moved here from its original location next to Adams Library, now the DuPage County Historical Museum, two blocks southwest. The brick bungalow-style house was built by Walter Kinnaman; the boy on the stoop shoveling snow is his son, C. R. Kinnaman. (Courtesy of Esther Kinnaman.)

Patrons conduct business in the ultra-mod, space-age lobby of the Gary-Wheaton Bank, seen here in the late 1960s. The bank maintained its central offices at 120 East Wesley Street, with a few satellite locations. In 1987, Gary-Wheaton (later First Chicago) opened a drive-up facility at 1800 North Naperville Road.

The U.S.S. *Wheaton* sails the high seas. Christened on March 22, 1945, at the California Shipbuilding Corporation yard in Los Angeles, the 10,500-ton vessel was named in honor of Wheaton College. After World War II, the ship brought troops home; later it was used to transport the bodies of soldiers killed in action. At one point, it was torpedoed by the Germans. (Courtesy of Wheaton College Archives and Special Collections.)

Cadets perform drills on the lawn of Midwest Military Academy, formerly the home of George Plamondon. The private school received boys in grades four through eight, teaching discipline and character. It was established in Wheaton in 1938. Promotional copy states that its "pleasant atmosphere, fine educational equipment, dedicated staff, live-in accommodations and a well-balanced nutritional program attract boys from all over the country." The photograph was taken around 1969.

Country Charm with City Convenience

Wheaton Center offers you the best of both. This truly unique community is not only the newest, largest and most innovative development in any of the suburbs but it adds a new dimension to this charming century old city. Our 760 spacious studio, one and two bedroom apartments are located in both high and low rise buildings on 14 lovely landscaped acres in downtown Wheaton. Right across the street is the new Chicago and North Western commuter station where you are only 35 minutes from the Loop. Every apartment is carpeted (with your selection), centrally air conditioned, has an electric kitchen, TV security system and anywhere from one to three balconies. You will enjoy our heated swimming pool, tennis courts, health club, social center and receiving room for your deliveries. If you're looking for the best in country-city living, Wheaton Center just might be your answer.

Wheaton Center

CARLTON AT LIBERTY

MODELS OPEN
WEEKDAYS: 11-7
WEEKENDS: 11-6

CALL - 653-2000

Greetings from Scripture Press

OUR pledge to you

We take very seriously our responsibility before God to publish ONLY Christian education material that exalts the Lord Jesus Christ. Now published in 85 languages and used in more than 120 countries. Scripture Press ALL-BIBLE Graded Sunday School lessons, Vacation Bible School lessons, Victor Books, visual aids, and other Christian education products are distributed by Christian bookstore dealers to thousands of Bible-believing churches around the world.

It is our purpose and promise to be faithful to our Lord in proclaiming His Word—Call the Scripture Press Bookstore for your Christian merchandise needs.
668-6000

THE WHOLE WORD FOR THE WHOLE WORLD

SCRIPTURE PRESS PUBLICATIONS, INC.
Wheaton, Ill. 60187

A page from an early 1970s promotional booklet displays an advertisement for Wheaton Center, located on property once occupied by the Chicago, Aurora and Elgin rail yard. Situated next to the tracks, the complex offers "country charm with city convenience." The copy confidently states that the center "adds a new dimension to this charming century old city." However, many citizens were not entirely thrilled when the concrete behemoths arose, forever blocking the skyline. The bottom half of the page is an advertisement for Scripture Press, a Christian publisher that has since been bought by Cook Communications; it is now located in Colorado.

Before assuming the responsibility of restoring the Wheaton Grand Theater (built in 1925), Ray Shepardson successfully campaigned for the preservation of movie palaces and opera houses in Detroit, Seattle, Los Angeles, Pittsburgh, Minneapolis, Chicago, and St. Louis. Because of his vision and enthusiasm, Cleveland's Playhouse Square, located in a once-blighted neighborhood, was rescued from the wrecking ball and skillfully rejuvenated, now hosting top-line attractions. He has been profiled by the *Wall Street Journal* and the *Detroit News* and is cited as one of "The 30 People Who Defined Cleveland." His magnificent obsession, guided by sensible thrift and a volunteer workforce, is to revitalize, as columnist Wolf Von Eckhardt writes, "a preposterous, gaudy, phony and beautiful part of America's greatness." Shepardson's wife, Nanette (below), stands in the lobby of the Wheaton Grand where the ceiling was refurbished by Dayton Spence, who also repainted the Cadillac Palace in Chicago. Once completed, the theater will function as a multi-use, high-tech arts and community center for the Chicago metropolitan area, focusing on family entertainment. (Courtesy of Ray Shepardson.)

Novelist Robert Goldsborough entered the mystery genre in 1986 with the publication of *Murder in E Minor*, after acquiring permission from the Rex Stout estate to continue the classic Nero Wolfe detective series, halted in 1975 upon Stout's death. Perfectly capturing Stout's voice, characterization, and narrative pacing, Goldsborough crafted six more Wolfe novels: *The Missing Chapter, Fade to Black, Silver Spire, Death on Deadline, The Bloodied Ivy*, and *The Last Coincidence*. Goldsborough inaugurates his own series with the suspenseful *Three Strikes You're Dead*, set in mob-infested, 1938 Chicago. The tale features Steve Malek, a hardboiled police reporter. Goldsborough, a writer and editor with the market journal *Advertising Age*, lives in Wheaton. He is one of 12 prestigious authors—including Garrison Keillor and Walter Wangerin—interviewed by Calvin College professor Dale Brown in *Of Fiction and Faith*. (Courtesy of Robert Goldsborough.)

Television viewers of a certain age fondly remember the matronly "Mama" Celeste Lizio from her 1970s commercials, in which she heartily exclaimed, "Abbondanza!", or abundance. Born in San Angelo, Italy, Lizio voyaged to the United States with her husband, Anthony, and eventually settled on the West Side of Chicago, where they opened the Kedzie Beer Garden in 1937. The Lizios sold the business in 1962 and began marketing Mama's tasty frozen pizzas to Italian restaurants. She later sold the recipe to Quaker Oats; but her likeness remained on the packaging. The Lizios resided in Wheaton. She died of heart complications in 1985 at the age of 80. (Courtesy of the Wheaton Historic Preservation Council.)

Tolkien and Lewis are not Wheaton's only fantasists. Len Bailey holds a copy of his novel, *Clabbernappers*, the first of a trilogy from TOR books. Jacket art is by Brett Helquist, illustrator of Lemony Snicket's *A Series of Unfortunate Events*. Bailey, a bagpipe player and commercial voice-over actor, lives with his wife and three buoyant sons in Wheaton. He attended Trinity College in Deerfied, Illinois, where he earned a bachelors of arts in history.

Fine storyteller Phil Vischer is founder of Big Idea Productions and creator of Veggie Tales. Due to shifting marketing strategies and other difficulties, Big Idea collapsed. For his newest venture, Jellyfish, he seeks to develop faith-based projects for families. He chose this name because jellyfish do not make big plans, and drift casually on currents rather than forcing their course. Vischer resides in Wheaton, where he maintains a studio. (Courtesy of Jellyfish.)

Farah Ahmedi, a 17-year-old student at Wheaton North High School, signs her memoir, *The Story of My Life, an Afghan Girl on the Other Side of the Sky*, at Wheaton Public Library. As a seven-year-old in Afghanistan, Ahmedi stepped on a landmine; resultantly, one leg was amputated below the knee, the other fused, rendering it inflexible. After two years of medical care in Germany, she returned home. Her two brothers fled, fearing recruitment into the Taliban; neither was heard from again. After another bombing killed her father and sisters, she and her mother moved to a refugee camp in Pakistan, then to the United States through the assistance of World Relief. Shortly after arriving in America, she met mentor Alyce Litz. In 2004, Ahmedi responded to a contest sponsored by *Good Morning America* and Simon and Shuster, calling for a 600-word essay. Sorting through 6,000 submissions, the judges chose three finalists. Her story won. The book was released on April 22, 2005, with Ahmedi embarking on a national tour. In 2005, she was honored as "Humanitarian of the Year" by Sir Paul McCartney; and *Teen People* magazine cites her as one of "20 People Who Could Change the World."

Whether one considers Jonathan Blanchard fearlessly battling the "peculiar institution" of slavery, or Todd Beamer foiling terrorists, or ordinary moms and dads simply holding down the home during a tight economy, Wheaton has not lacked for heroes: men and women who have sacrificed, often dearly, for others. A sterling example is Sgt. Joel Gomez. Gomez, a U.S. Army Specialist, had been stationed in Iraq for two weeks when the Bradley fighting vehicle he was maneuvering rolled off a steep embankment. With him were two soldiers who died as a result of the accident. Joel was flown to Germany for medical care before transferring to Walter Reed Hospital, and then to Edward Hines Jr. Veterans Hospital in Maywood, Illinois. In Germany, Secretary of State Colin Powell honored him with the Purple Heart. Joel is now able to speak and eat through means of surgeries and therapy, but he will be paralyzed from the neck down for the remainder of his life. His parents are Algimiro and Emilia Gomez, members of the Wheaton Bible Church Hispanic Congregation. The author respectfully submits this entry as a concluding response to the initial query, "What's so great about Wheaton?" (Courtesy of Wheaton Bible Church.)

ACKNOWLEDGMENTS

Sincere indebtedness is expressed to these kind hearts: David Malone and David Osielski of Wheaton College Archives and Special Collections; Betty and David Bland, Glenda Gingras, Leon Frankel, and David Bruce, my friends at the Theosophical Society; Ruby Call; Len Bailey; Phil Vischer; Farah Ahmedi and Alyce Litz; Dick and Char Burghardt; Dave Thomson; Seth Meyers; Scott Albert; Betty Smartt Carter; Alberta Adamson and her staff at the Center for History, Jamie Kelly and Wendy Miller; Ray and Nanette Shepardson; Gerald and Jane Hawthorne; Robert Goldsborough; Chuck and Vicki Kinnaman; Esther Kinnaman; Sword of the Lord; Bill Rice III; and the Wall family, especially Buddy, for moral support. Finally, to Ann Marie Lonsdale, who with her red pen, scalpel-like, hurts to heal. Every effort has been extended to secure permission for all images. If I have forgotten anybody, it is not insufferable ingratitude but rather my own faulty memory.